5 00
OCE

THE
MODERN
PRIMITIVES

Translation: Bernard Jacobson

Editorial Director: Jean Saucet.
Design: Jacques Segard, assisted by Alain Viard,
 with Alexander Soma.

© Copyright 1977 E.P.I., Editions Filipacchi.

© S.P.A.D.E.M./A.D.A.G.P.

English language edition:

© Copyright 1978 Images Graphiques, Inc.
37 Riverside Drive, New York City 10023

Library of Congress Card Catalog Number: 78-58298

ISBN 0-89545-020-8

Printed by H. Fournier, S.A. - Vitoria - Spain

THE MODERN PRIMITIVES

Instinctual Painters

Text by
Madeleine Gavelle

Images Graphiques/New York

Academy Editions/London

Primitive art has existed since Man came into being. And ever since the beginning of mankind this art has been innocently fantastic, candidly surrealistic, ingenuously unsophisticated.

Are there, anywhere, more spontaneous, more instinctive, more naive drawings than the cave paintings of Altamira, of Lascaux? And yet, we may say that all the art of the world stems from this art. From cave paintings to votive offerings, from sign boards to portraits, primitive art has always been—above and beyond popular or folkloric imagery—the expression of a great pictorial current, indeed of a real artistic current.

It is our purpose here to present a panorama of the so-called "primitive" painting through its principal artists. It is a selection we offer the devotee, as well as a tool for the novice. Obviously, the selection has been, like any choice, wrenching, but it was important to represent what we thought was essential to this artistic current rather than to risk a fastidious enumeration.

The reader will note that this choice covers many countries; Poland, Holland, Switzerland, the United States and Brazil are represented, among others. However, we may declare firmly and without any chauvinism whatsoever, that France is primitive art's mother country, par excellence.

Rousseau's importance in the realm of primitive painting derives from the fact that before his appearance on the scene this mode of expression was essentially anonymous. It was the work of people who had other "trades," not professional artists. Art history and the critics haughtily ignored the primitive current. Then Rousseau arrived on the scene, and the existence of spontaneous painting was then acknowledged, even baptized, and it became possible to associate other "non-professional" painters with the designation "primitive."

Although the powers that be in art circles in France are officially cool to primitive painting (the most beautiful primitive paintings are buried in the cellars of the Paris Museum of Modern Art, in spite of the donors' wishes), the United States, Italy, Switzerland, and Japan have recognized it as a noble and separate art form in its own right.

But these naive painters, or "20th century primitives," "Masters of the sacred heart," "Popular masters of reality," as they have been successively called, present a problem. They are, on the whole, nothing but individuals. Obviously excluded from this judgment are the Yugoslav peasant-painters who are grouped in the communal school of Hlebine, and the Haitians, mostly priests, drawn together by the voodoo cult, who belong to the famous school of Port-au-Prince. But, in general, the primitive painters do not belong to schools, rely only on themselves, imitate no one, and have no masters. They freshly invent their technical approach with each picture. They have "the wonder-struck and searching awkwardness of primitive art" (Apollinaire). We understand that with these men and women, mostly from the lower classes, who often waited for their retirement to paint outside on Sundays, what counts most and legitimates everything is sincerity and authenticity. They paint from the heart. They are the poets of our new prehistory, of the time that preceded the machine, output, plastics.

Their inspiration is often unexpected, moving from a totally anecdotal subject to a historical or a Biblical scene, as if impelled by an imperious need to find the roots, the

foundation of their existence. They have a predilection for legends, jungles and wild beasts, and they find in their inner self, in a motionless voyage, what a Gauguin was looking for in the South Sea Islands, what a Picasso discovered thanks to Black art. Since they are not interested in intellectual ideas, they remain safe from sterile research. They are not concerned with the problems of light or the study of spatial relations, nor with any stylistic device. The supreme self-confidence of primitive painting protects it from social, artistic and spiritual cataclysms which in the past few years have been unleashed by men intoxicated with their own technique, moonstruck by their discoveries, by apprentice sorcerers, deicides. This painting makes us happy and that is something which Max Jacob considered the only criterion of good painting.

Nevertheless, the primitive painters were launched by intellectuals who had been impressed by their frankness, by their unconscious originality, by their natural "anti-cerebralism." Moreover, we should not think that the primitive painters exist in a ghetto decked out with clichés: freshness, innocence, return to nature. Naive painters have anxieties. Nikifor's frozen, deserted streets, Séraphine's thicket of eyes, breasts and feathers, and Vivin's negative, hermetic structures—don't they originate in troubled psyches? They are disturbed but unaware of it.

Their technical "ignorance" is compensated for by a certain state of grace which allows them to introduce unforeseeable discoveries and bold but unconscious inventions which would never be authorized by established painters. They are humble, full of love; they don't want to prove anything and they don't want to invent anything. They do not try to promote art, yet their works do so unintentionally, and the best among them even add to our knowledge of technique: Rousseau by virtue of his composition and the density of his material; Bauchant by virtue of his subtle color harmonies; Bombois by dint of his solid realism. And despite the fact that the primitive painters' preoccupation is not metaphysical, Malraux was nevertheless able to write of Rousseau: "Although he measures his models' noses, his painstaking art, like Bosch's, is a fantastic art. This art does not at all define itself by what he sees . . . but rather by the pictorial quality of what he dreams. His painting "L'Octroi" (The Assessment) is worthy of an Uccello but it is also a haunted landscape."

The term "naive" sometimes used for the modern primitives requires a clarification: it is an early designation, practically invented by Rousseau who was an "unconnected" painter. His successors made—as he had—a few technical mistakes, a few blunders. Consequently, they were called "naive" painters. But the fact that we still use this expression stems from a lack of criteria. Primitive painters are enlightened by their instinct— that is their common denominator. They all express themselves "without having learned," but they do not speak the same language. How can we join together under one flag painters as unlike as Generalic and Lefranc, Van der Steen and Fejes, Rabuzin and Jean Eve?

How can we reconcile the soft, muted colors of a Bouquet or a Schwartzenberg with the color explosions and contrasts of the Haitians and of certain Yugoslavs? We would suggest to differentiate between two tendencies: The *super-realists* and the *visionaries*.

Of the first group, let us say that their approach is quasi photographic; they are

"premature" hyper-realists but they paint in a different spirit. Indeed, if the hyper-realists copy reality, "maximize" it, but do not go beyond it, our super-realists, on the other hand, think they are copying nature, but they are actually painting their dreams. They add something vague and indefinable to reality which makes them go beyond it. Their imagination is disguised as reality. Their art approximates that of the visionaries but their expression is different because it is soothing. The case of Lagru is quite typical because only his inexhaustible readings could have inspired his pre-historic landscapes, his mammoths, deluges and Golgothas which he depicts as if he had painted them from nature. The same can be said of Peyronnet and his surprising linear, almost abstract seas, and of Jean Eve whose "purity" sublimates every landscape; as well as of Rimbert who finds in his head and in his soul the unforgettable light of his paintings. They are all the faithful interpreters of their memory's haunted landscapes. The innocent appearance of super-reality is but an inner spark that intensifies the canvas, transcends the commonplace, communicates the density of life. These painters go much farther than they suspect—they are the sorcerers of banality, the diviners of the subjacent.

The visionaries have a phantasmagorical approach to the world which becomes obvious in their most commonplace scenes. Their "surrealism" is subconscious and often stems from the shock of incongruous, improbable encounters (a mermaid in Focus' sky, a couch in Rousseau's jungle). They paint a mirage, the illusions of their heart, and the dream-world they create is already beautiful. They are strange realists, halfway between the supernatural and the fantastic. Their painting is a reflection of their most profound being, a snapshot of their inner ecstasy, of their subconscious. They paint the formulation of a dream, of a fixed idea, of a cosmos in harmony with "their" planet. Rabuzin is one of the masters of this genre, with his ideal reconstruction of a poetic world, but Séraphine with her mystic hallucinations, Van der Steen with his half-diabolical, half-sacred animals and Naumowski with his undulating dreams of germination, of life, and of death, have also pushed back the commonplace in order to present to us the allusive associations of their hallucinations.

But all of these painters—super-realists and visionaries alike—simply present us with their dream images. They have the candor of people with pure hearts; they have the conscience, the love, the patience of craftsmen who have done their job well. They don't embellish, their modesty is extreme, they do their work with a great economy of means. "Are they even aware," Malraux used to ask himself, "of their greatness?"

They are primitive painters by instinct, miraculously linked to the creators of cave paintings, to the illustrators of the Book of Hours, to the builders of cathedrals—linked by the same unmitigated fervor. They are the guerrillas of modern art. They are the living proof that art is within man in an embryonic state, that man, even lacking culture, is ready to absorb civilization by osmosis and that, whoever he may be, wherever he may come from, man has a right to art.

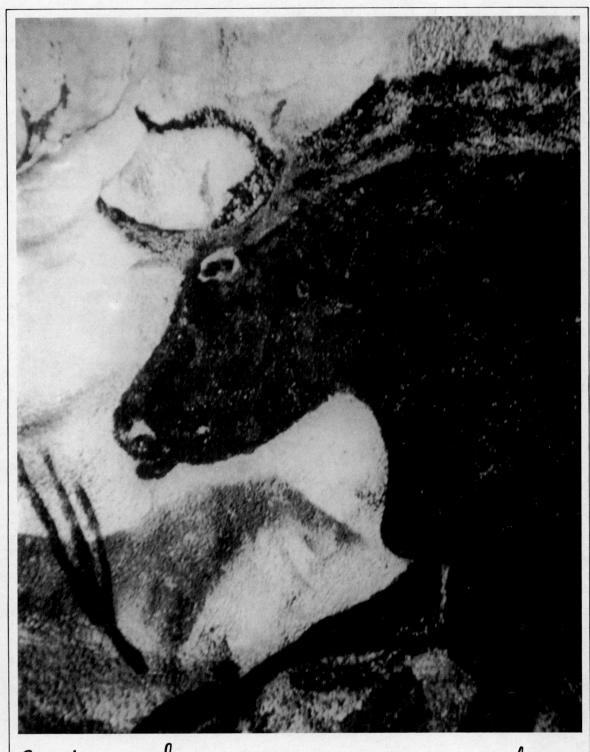

*Primitive Art has existed since man came into being.
And ever since the beginning of mankind...*

10,000 years ago, on a cave wall, at Lascaux. . .

In 1975, in Paris, on a wooden fence around "Les Halles"
(see double-page spread which follows)

INSTINCTUAL PAINTERS

expression are absolutely personal despite a favorite subject which she shares with Rousseau: the jungle. But she was familiar with these jungles and all its great wild beasts because she spent her childhood there, while poor Rousseau, who was a mere retired customs inspector, invented them with all the immense richness of his imagination. She possesses a very sure sense of composition and balance. But, though her naiveté is more forcefully expressed in her urban landscapes, her skill is much better revealed in her tropical forests, a universe where she is instinctively at home, where she has roots.

ALEXANDRINE

She was born July 31, 1903 at Djokjakarta, Java (now Indonesia). After leaving the island she married a painter-sculptor, and moved to Holland and later to France, where she discovered the skies of Provence, the commotion of cities, their cathedrals, the countryside with its parish priest and lovers. Her means of

BAHUNEK

Anton Bahunek was born in Varazdinske Toplice, Yugoslavia, in 1912. He worked as a house painter and sketched a bit for his own pleasure; before World War II he began to paint. His work was noticed by the administrators of the Zagreb Museum of Primitive Art and as a result he participated in group showings in Italy, Belgium, Germany, England, as well as in Paris. Bahunek occupies a very special place in the Yugoslavian pictorial context. He does not belong to any school, and his pointillist expression is totally self-invented, since he is not aware of the technical and scientific research of such painters as Seurat, Signac and Cross. Because of this he has many admirers. By the use of blunt colors which are muted by the value differences of his "points" he creates perfectly balanced, very well constructed planes. His landscapes with their characteristic thickets, his mammiform hillocks, his strange flowers, his deserted countryside sometimes, although reluctantly, it seems, disturbed by the silhouette of an iridescent horse or a flight of ducks, reflect a very harmonious world which bears the poetic mark of the painter and his dream of peace and calm.

ALEXANDRINE: Jungle. 1965. 62 × 80 cm/24.5 × 31.5 in

BAHUNEK: The Two Bell-Towers. 1972. 65 × 55 cm/25.5 × 21.5 in

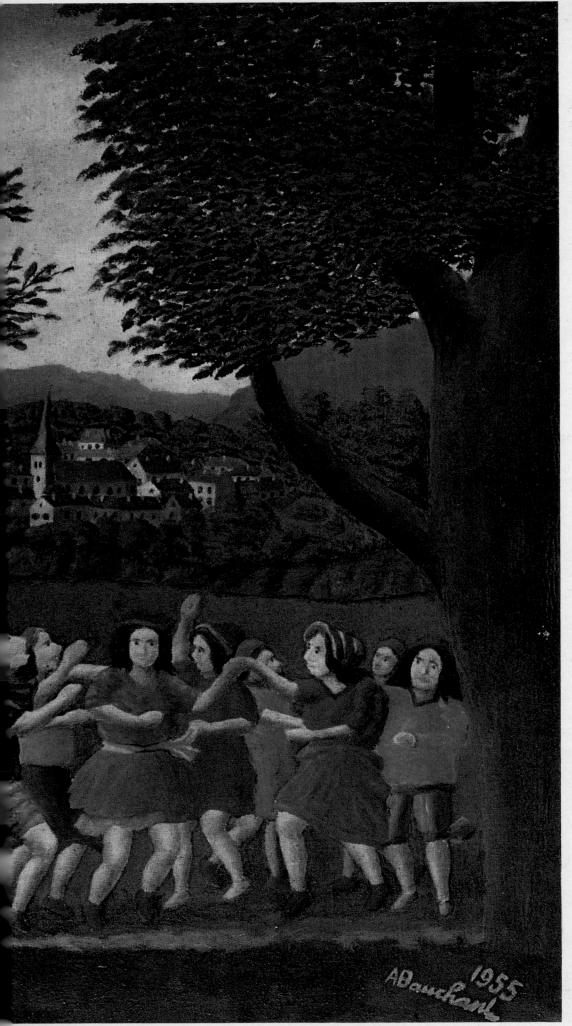

BAUCHANT: Ring Dance. 1955. 55 × 72 cm/21.5 × 28.5 in

BAUCHANT

André-Auguste Bauchant was born in 1873 at Châteaurenault, France. His father was a gardener, his mother a seamstress. He died in 1958 at Montoire-sur-Loir. He became a gardener like his father, married in 1900 and, with his wife's help, founded a horticultural enterprise where he planted, grew, cared for and sold trees and flowers which he later reproduced on his canvases. In 1914, he was drafted and sent to the Dardanelles. It was an extraordinary whim of fate that chose to assign him there, since, as a young child, he had been fascinated by Greco-Roman history and, above all, mythology. In any case, this voyage was a dazzling revelation to him, placing him face to face with the school images which had so fascinated him. Later, when the time came, his formidable visual memory was able to restore for him the colors, the forms, the atmosphere. Suddenly, as a result of an illness, he was returned to France and assigned to the telemetric service in Rheims. He became aware of the ease with which he was able to draw up plans, and at the same time he discovered his talent for drawing and began to paint. After his discharge from the army, he found his nursery in shambles and his wife, who had become insane, locked up in an asylum. In order not to be separated from her he built a wooden house near her and painted and cultivated his garden. As any creative artist, he had the desire to exhibit his work and, without knowing anyone, sent his paintings to the 1921 "Salon d'Automne." It was there that Le Corbusier noticed his work and started buying his paintings. In 1927, Serge Diaghilev commissioned him to create the decor for his ballet "Apollo, Chief of the Muses," the music for which had just been written by Stravinsky. "Apollo" was an ideal subject for Bauchant who, without having the slightest idea of the music, and with his masterly

innocence, created a decor that was extremely well adapted to this sophisticated score. It was an immense success but Bauchant kept a cool head and returned to his garden. Thanks to the selections of the great art lover, Uhde, he exhibited in 1931 with the "Painters of the Sacred Heart," then in 1937 at the "Popular Masters of Reality" show he exhibited alongside Rousseau, Bombois, Séraphine and Vivin. His work now began to acquire international fame and, consequently, in 1948 at the Charpentier Gallery a retrospective show was organized which stands as the highpoint of his career. Nowadays his works can be found in the museums of modern art in Paris, in many foreign museums and in private collections. He became a widower but remarried. His painting is typically that of a naive visionary who combines the greatest innocence with an inborn sense of the theater, of composition and staging. His lyrical imagination restored to him the mythological scenes of his school books; he painted them with a sense of the highly marvelous and a constantly fresh poetry, mixing the fantastic with the commonplace with a parallel exaltation and calmness. From which unexpected folds of his brain come the sometimes baroque, sometimes grotesque works of unconscious humor, the circumstantial solemnities of so many compositions whose titles are already quite a program: "Pericles Justifying the Use of the Public's Money," "Louis XI Having Mulberry Trees Planted Near Tours," and so on? Is it the closeness, for so many years, to an insane woman that spurred him towards greatness and glory ("The Gods of Olympus") and calm and peacefulness ("Flowers and Landscapes of the Country of Tours")? His paintings burst into color, joy, life—everything which his poverty, his isolation and his hard work deprived him of. Even when his palette becomes more

BAUCHANT: Mountain Stream. 1930. 54 × 50 cm/21 × 19.5 in

BAUCHANT: Nativity. 1943. 45 × 38 cm/17.5 × 15 in

muted, his hues softer, less emphatic, there remains always a density, a presence, real invention. And in all cases, with this peasant-painter, there is a subtle understanding of the poetic value of certain alliances of form and color, virtuosity and clumsiness; he ranks in importance right after Henri Rousseau.

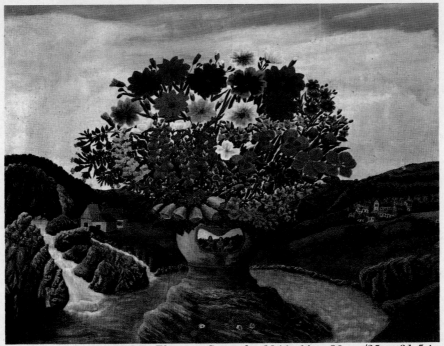

BELLE: Flowery Cascade. 1946. 64 × 80 cm/25 × 31.5 in

BELLE: The Happy Island. 85 × 115 cm/33.5 × 45 in

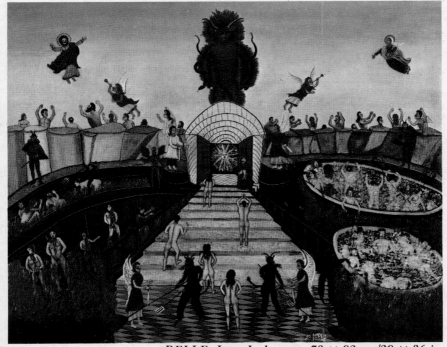

BELLE: Last Judgment. 73 × 92 cm/29 × 36 in

BELLE

Narcisse Belle was born September 9, 1900 at Saint-Sylvain (Creuse), France, and died in 1967. A butcher's helper, cook and later a market porter at the Paris Halles, he started to paint during his military service. And he did so with love and dedication but this did not bridle his imagination. Jeanne Bucher and André Salmon encouraged him but Narcisse Belle painted very little and this made it difficult for the galleries to invest in his works. His first show took place in 1943. His most intimate wish was to cultivate the soil, to produce the most beautiful flowers simply so he could look at them, paint them . . . but life condemned him to cart slaughtered animals. And we sometimes think that fate was right to deny him his vocation because, otherwise, he would have cultivated flowers and not the paintings which he created with such passion and which allow us to penetrate his so involuntarily innocent and bizarre vision of the world and the main events that take place there: the past, the future, everything inspires him. To wit, this fabulous "Last Judgment" which goes far beyond the anecdotal and lets us see how a fellow human being portrays this supreme moment and this "Island of Happiness" towards which we would gladly set sail.

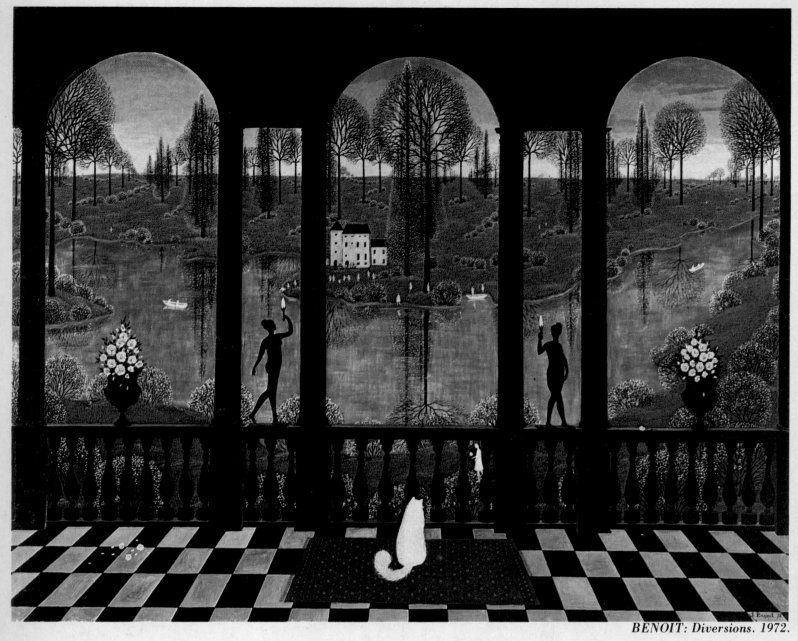

BENOIT: Diversions. 1972.

BENOIT

Jacqueline Benoit was born January 6, 1928; her parents had a small business. She has been painting full-time since 1954 and has participated in the most important international exhibitions and shows of modern primitive art. Consequently, she became known to the general public. In 1975, the Museum of Naive Art of the City of Laval devoted an important show to her work. Her pictorial language is very particular: when we look at her paintings we get the impression that we have entered her world uninvited. This so revealing universe of the artist's obsessions fascinates us and attracts us like a forbidden fruit. We do not easily forget, once we have encountered them in her paintings, her green and frozen landscapes where not the least wind blows, her rivers, this entire "suspended" universe which is suddenly humanized by women on the run, an angora cat, living flowers, the transparency of a veil. A psychoanalyst would be daring if he thought he could interpret all this by explaining the themes. The truth lies elsewhere, deeply rooted in the precise poetry, the dream that has become reality in Jacqueline Benoit's world. Go to the Convent of the Beguines in Bruges, in the cloister's inner garden, with its lay sisters among the trees, and you will find yourself inside one of Jacqueline Benoit's paintings. And, paradoxically, this may well be a painter's greatest success: to induce a landscape to resemble her paintings. Jacqueline Benoit does not just paint on any motif, the outline must be etched in her head or it will not reach her brushes. She is a thinker driven by an aesthete's instinct, a sensitive person bound by her lucidity, by her self-imposed rigor. Jacqueline Benoit's art, her silence, her subtle and involuntary dosage of modesty and shamelessness, of fire and of ice transcend loneliness and gives us peacefulness. A cool visionary, she is one of the few whose delirium is not disorderly. It is precise, constructed, but with an added touch of soul.

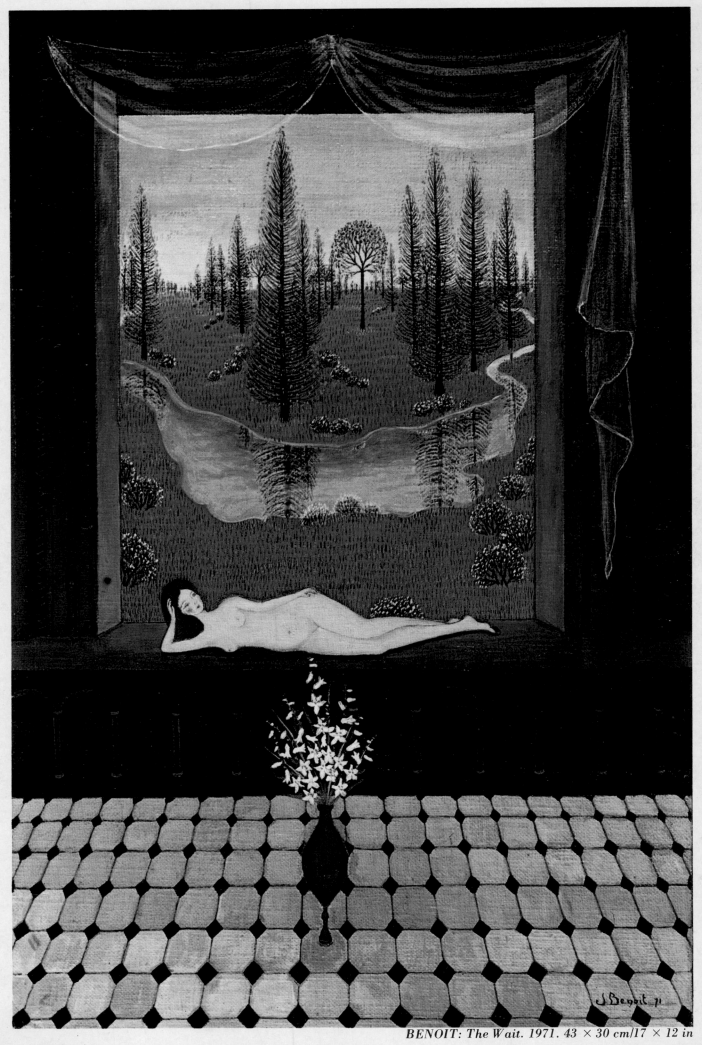

BENOIT: The Wait. 1971. 43 × 30 cm/17 × 12 in

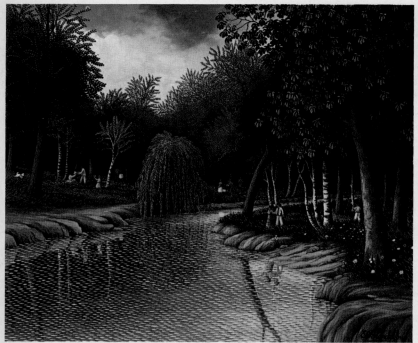

BLONDEL: The Willow. 1959. 60 × 73 cm/23.5 × 29 in

BLONDEL: The Lake. 1956. 50 × 60 cm/19.5 × 23.5 in

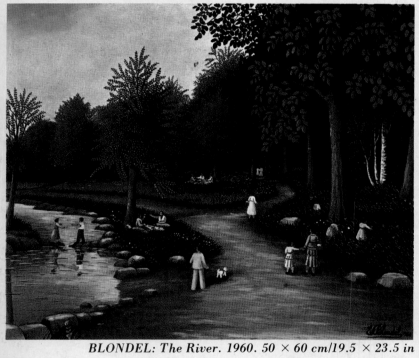

BLONDEL: The River. 1960. 50 × 60 cm/19.5 × 23.5 in

BLONDEL: The Gay Old Spark. 1957. 46 × 55 cm/18 × 21.5 in

BLONDEL

Emile Blondel was born August 6, 1893 in Le Havre, France, and he died in 1972. At a very young age he was already attracted to drawing and painting; at age 16 he worked as a deckboy on Newfoundland fishing vessels, then as a longshoreman, farm worker and bus driver in Paris, namely on the "J" line which linked the Place Saint-Michel with Clignancourt. His health was poor, he suffered from asthma, and he waited for his retirement, in 1950, to devote himself truly to painting. His discovery may well supply an impetus to a new wave of great modern primitive painters to take the place of painters like Rousseau, Bauchant, and Bombois . . . Blondel was an uncompromising artist. All his life he resisted the temptations of success and money. He refused contracts which would have forced him to paint a set number of canvases. He was not concerned with glory, connections, ambition; he let his admirers and patronesses help him without becoming conceited. Scrupulously thorough and attentive, he showed great respect for time. "A naive painter," he used to say, "can't be young because the work requires renunciation and abandon." A mystic, he also painted several religious scenes but not without obtaining the pertinent documentation from the clergy. He loved music and poetry and quite often his paintings were accompanied by very simple, pure, tender little poems: "O Our Lady of Paris, You who has the soul, the heart, the beauty, the refuge of our life, You who soften our misfortunes which the entire world longs for, O soft twilight, the Silent evening on the banks of the Seine which is in Paris falls asleep and says good evening to you, I lay at your feet my Joys and my sorrows while praying before your beautiful mirror which I would forever like to contemplate at night." (Poem written on the back of a painting

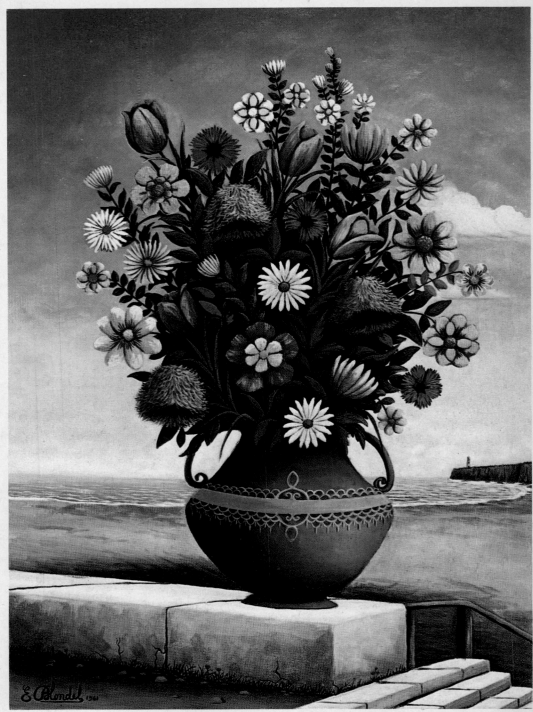

BLONDEL: Bouquet on the Beach. 1961. 61 × 50 cm/24 × 19.5 in

representing the Church of Notre Dame.) Enlightened by an immense inner light, he sublimated his neighborhood with his lawns, his rivers, his marvelous bouquets of flowers and his trees—his trees, above all, whose every leaf he sketched with love and precision.

RAYMOND PHILLIPS

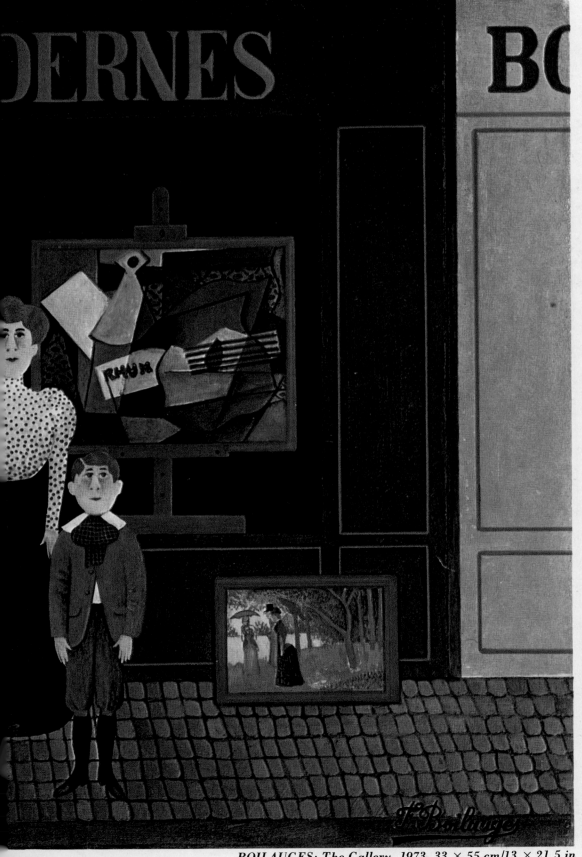

BOILAUGES

Fernand Boilauges was born in 1902 in Lille, France. He began his career decorating village stores, painting signs, letters, imitation marble and imitation wood. Since this kind of activity was rather limited he traded his brushes for a camera and soon specialized— probably because of his talent for staging—in photos of family groups. It was then that he had the idea to go back to his brushes and to put on canvas the same scenes which his lens had focused on. To this he added his first love—that is to say, as a backdrop he created carefully decorated shops. He exhibited at the "Contemporary Primitives" show at the Charpentier Gallery in 1955. He participated with other primitive painters in a show which had as its theme "scenes from French life." Subsequently, he became well known, notably in the United States, and many Hollywood stars were among his early customers.

His precise style almost makes him a premature "hyperrealist." His ribbons of pompous people perfectly playing their role evince a humor which one can hardly consider totally involuntary. Isn't it with a twinkle in his amused eye that Boilauges offers us this art dealer's store front where, just for the fun of it, he slipped in paintings by Juan Gris, Toulouse-Lautrec, Renoir and Picasso? But let's not spoil our pleasure. His style is good and his work well made, and his personality original enough so that his paintings are now listed in the catalogues of the greatest international shows.

BOILAUGES: The Gallery. 1973. 33 × 55 cm/13 × 21.5 in

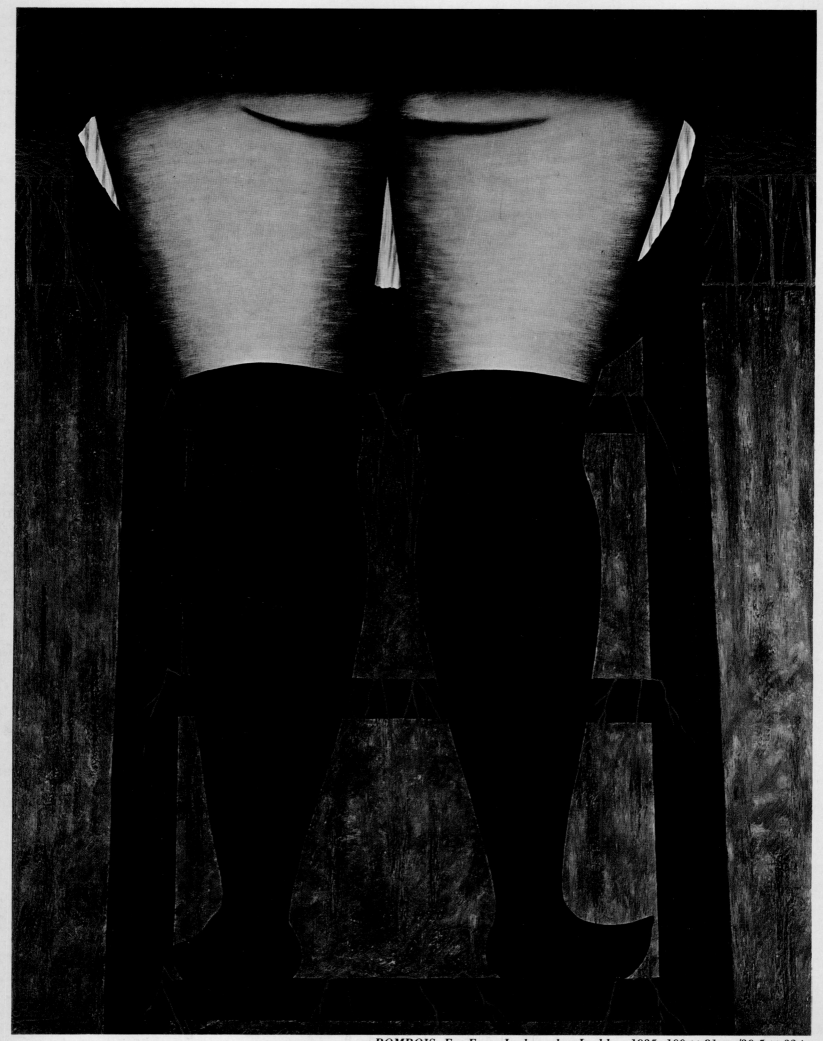

BOMBOIS: *Fat Farm Lady on her Ladder. 1935. 100 × 81 cm/39.5 × 32 in*

BOMBOIS

Camille Bombois was born February 3, 1883 at Venarey-les-Laumes, France, and he died in 1970. The son of barge people, he became a farm boy at about age 12, worked on road repair, then as a circus worker, side show athlete, construction worker and finally as an unskilled laborer in a Paris printing plant. He picked this trade, which required a strenuous effort, because it could be done at night, and in this way Bombois, who since age 16 dreamt only of painting, finally succeeded in seeing daylight. He used the many hours of natural light to paint the rivers and barges of his youth, the universe of circus people, athletes, jugglers, powerful fleshy women. He had an affinity for the latter, and his wife served him as a model. Having no imagination, he painted reality the way he had seen it. Curiously enough, moreover, he always started his paintings from the bottom, and little by little built up his decor. The sureness of his hand, the precision, the smoothness of execution attracted many collectors. And he had the good fortune of being appreciated and sought after in his lifetime. Conscious of the value bestowed upon his paintings, he ended his career working mostly on small sized works. Even though he was somewhat troubled by his success, he remains one of the five great modern primitives, one of those who showed the way to the others.

BOMBOIS: The River Clain at Poitiers. 1947. 19 × 27 cm/7.5 × 10.5 in

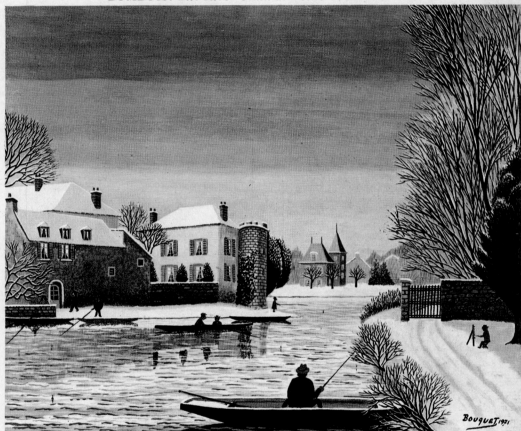

BOUQUET: Moret under the Snow. 1971. 46 × 55 cm/18 × 21.5 in

BOUQUET

André Bouquet was born in 1897 at La Varenne-Saint-Hilaire, France. He worked successively as a butcher, cook and quality inspector in a factory. He lived through two world wars (including the Indochina Campaign of 1919) and suffered the most cruel family tragedies; but these heartbreaking events, these horrors neither unsettled nor affected the equilibrium and the serenity of his life. For he has that powerful and fantastic unconscious or resigned philosophy of the people, of which he is an authentic and uncompromising representative. This same equilibrium, this same serenity can be found in his paintings. For, in 1950, driven by we don't know what force, he started to paint at the age of 53. From then on he daily pursued the only joy in his life: his canvases, his brushes, and all the marvelous landscapes which are on his mind and whose intimacy he tries to convey to us. He plays, as a lesser player, for our enjoyment and his, great music in concert with Rimbert, Blondel, and Jean Eve.

BOYADJIAN

Micheline Boyadjian was born
April 27, 1923 in Bruges, Belgium.
Before her wedding to a doctor
she was working as a secretary. She
began to paint around 1954, after
having taken a few evening art
courses. She is a visionary of the
commonplace as well as of the
unusual anecdote: she paints her
monuments, her houses, her
interiors—often devoid of people
but always symmetric and reduced
to essentials—in a structured and
constructed manner. And it is this
notion of symmetry which is most
obvious in her work. By what
supreme need for justice, for
equilibrium is she obsessed, for her
paintings seem to be one half
painted and the other half a
mirror reflection of the first?
Contrary to Valery's Narcissus
who, looking at his reflection in the
water, dreaded the evening which
"slides between the two of us the
blade that cuts the fruit,"
Boyadjian's people do not look at
each other, they look ahead toward
some unknown great Beyond...

CAILLAUD

Aristide Caillaud was born in 1902
in Moulins, France. His childhood
was dominated by the influence of
his father, a peasant poet, who
revealed to him the beauty of
nature, and by his maternal uncles,
weavers all, whose technical
patience he assimilated. He started
painting seriously only in 1941, in
a German prisoner-of-war camp.
He worked with Max Ingrand who
encouraged him from the
beginning. In 1945 he left his small
food business in order to devote
himself to his art. Caillaud is the
most universal, the most powerful,
the richest of our visionaries, the
one in whom the battle between
the great hope for happiness and
the visceral anxiety of man is being
fought. He is acutely aware of the
simultaneity of the forces of Good
and Evil. But he also seems to be
on the other side of things, of God
and the Devil, of heaven and earth.
Pierre-Jakez Hélias' "Horse of

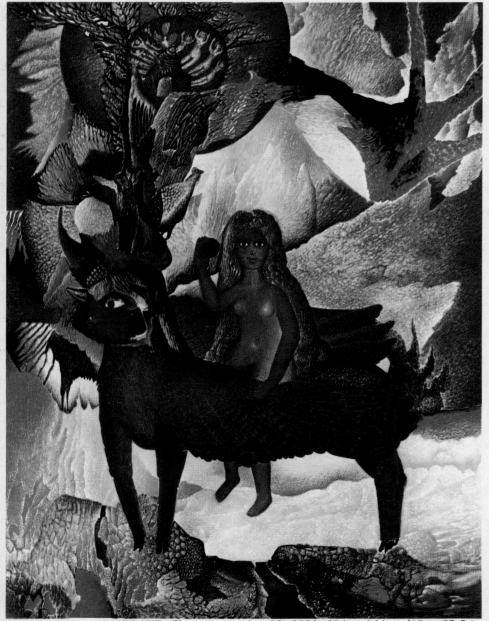

BOYADJIAN: *Two Little Girls. 1969. 73 × 90 cm/29 × 35.5 in*

CAILLAUD: *Veronica at Age 12. 1972. 114 × 146 cm/45 × 57.5 in*

Pride" seems to illustrate Caillaud. "The trees work, they bind heaven to earth . . . heaven is so light that it forever seems to run away. If there were no trees it would say farewell to you. Where there are no trees, there are no people, Heaven has become unhooked." The roots seek their way in the soil and the branches violate the heavens. Heaven resists, and to keep it in place Caillaud assigns a procession of petrified rocks, fishes, birds, eyes, suns, and outstretched arms to hold it back. His painting is ascensional. It is an offering to heaven, a mystic flash, the conflagration of a soul transfigured by its creation of Creation. His tenderness, his passion for origins, for spheres, his cosmic impulse sanctify in his paintings his fellowship with all the elements, with all of God's creatures.

DELACROIX

Michel Delacroix was born February 28, 1933 in Paris. Unlike most of the Primitives, he studied art: he received a bachelor's degree and a professorship of design. Hence his artistic pursuits are buttressed by a technical know-how which the others do not have, but we must understand that in the world of the naive painters there is a kind of inherent justice which gives to one and takes away from another; it preserves a subtle equilibrium . . . Delacroix is an experienced craftsman. He is an anxious creator, but anxiety is the good fortune of creators, of those who "push ahead." And from one canvas to the next, this painter of a single theme, the facades and streets of Paris, progresses, and unceasingly asserts and imposes himself.

DEMONCHY

André Demonchy was born September 14, 1914 in Paris. He became an orphan as a result of the war. He was cared for by the Public Welfare Bureau. He took a job with the National Railway

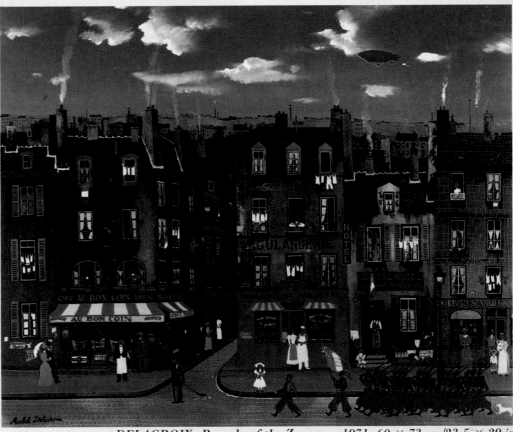

DELACROIX: Parade of the Zouaves. 1971. 60 × 73 cm/23.5 × 29 in

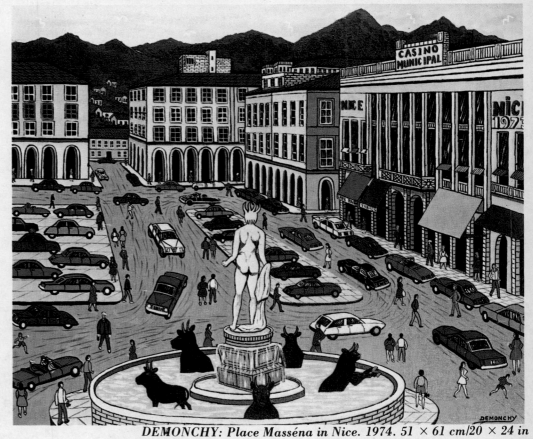

DEMONCHY: Place Masséna in Nice. 1974. 51 × 61 cm/20 × 24 in

Company at the Saint-Lazare Station. Of course, he paints railroad stations and trains but also castles, churches and rural landscapes. All this is normal, tranquil, skillfully done, and suddenly, in a roundabout way, on a very classical painting of Nice's "Place Masséna," for instance, the

bewildered eye notices bulls frolicking in the fountain. The eye knows—but it forgets—that in Nice there are actually sculptures of bulls but they are academic, respectable. Demonchy's bulls are evidently the product of his imagination: they jump, they are alive, they frolic in the water!

25

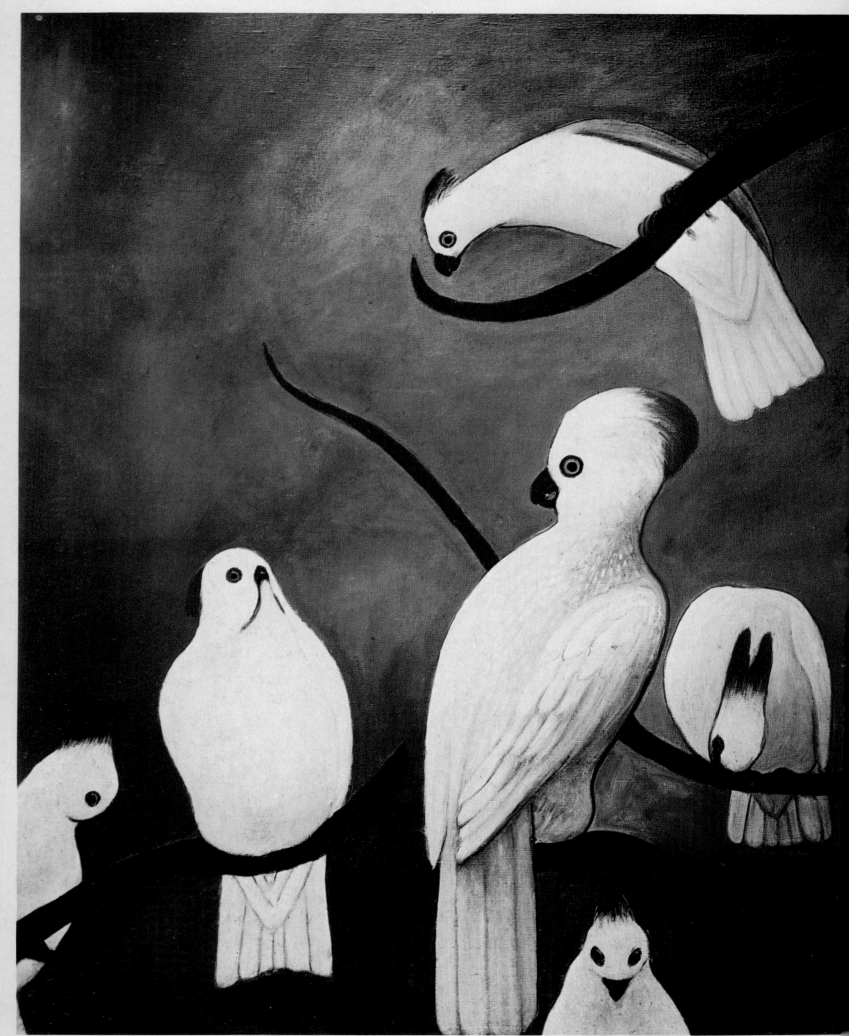

DESNOS: *Cockatoos*. 1935. 81 × 65 cm/32 × 25.5 in

DESNOS

Ferdinand Desnos was born in 1901 at Pont-Levoy (Loir et Cher), France; he died November 16, 1958 in Paris. He began his working life as a vintner's helper. Because of his precarious health, he was quickly driven to an unstable life. He worked as an electrician and, in 1928, as a janitor in Paris. He was poorly adapted to life and failed to assume his family responsibilities. But, preoccupied only with painting, he transcends the commonplace and expresses himself with an inner intensity that makes his paintings border on the surreal. As a moral visionary, he is obsessed with certain personalities of great spiritual quality: Don Quixote, Francis of Assisi . . . as well as by certain somewhat magical animals: cats, exotic birds . . . by certain religious and mythological scenes: the Annunciation, Leda, Castor and Pollux . . . He is a quadratic visionary. Van Derpyl discovered him and helped him exhibit at the "Indépendants" show. An amazing colorist, he cannot be compared to any other primitive painter: he knew nothing about mixing colors, and used them the way they came out of the tube, but the magic of his vision always made up for his technical shortcomings. Desnos is the forgotten genius, the most unjustly bypassed of all the primitive painters. Only Ghez, in his remarkable collection of "20th Century Primitives," at the Petit Palais in Geneva, assigned him the important place he deserves. He is cast in the mold of the great artists. The supernatural of his imagination, the recreation of his inner world are ample proof of this.

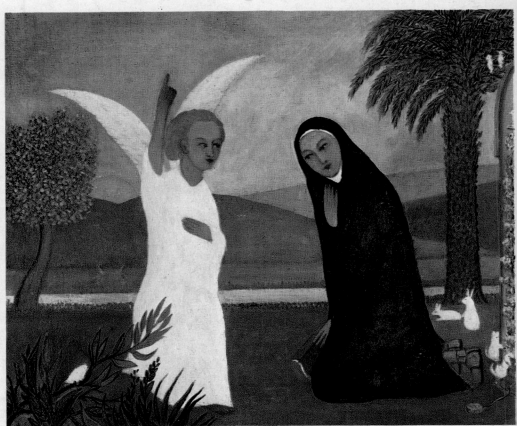

DESNOS: The Annunciation. 60 × 73 cm/23.5 × 29 in

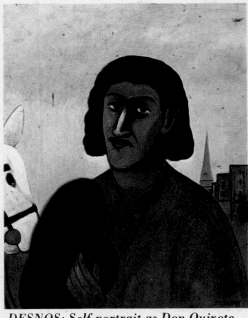

DESNOS: Self-portrait as Don Quixote.
53 × 44 cm/21 × 17.5 in

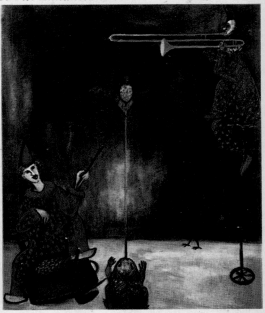

DESNOS: The Clowns.
49 × 47 cm/19.5 × 18.5 in

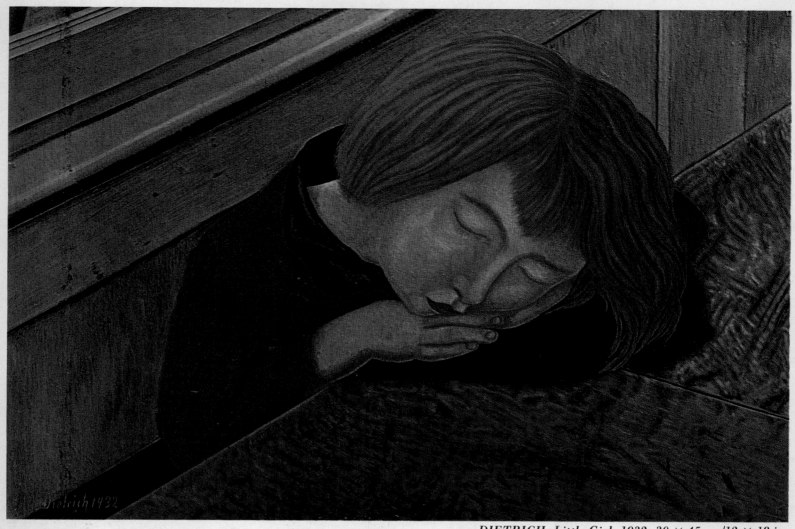

DIETRICH: Little Girl. 1932. 30 × 45 cm/12 × 18 in

DIETRICH

Adolf Dietrich was born in 1877 in Berlingen, Switzerland, and he died in 1957. The son of peasants, he lived his childhood in poverty. He worked successively as a farmhand, a logger, and a weaver, but soon started to paint out of inclination and also necessity, for like the famous American commercial artists he accepted commissions to paint his neighbors, their homes and their domestic animals. A Bernese painter, Volmy, who was passing through his village, encouraged him to persevere. Finally, by 1926, he managed to live off his art. He was a keen observer and painted with great skill. His very impersonal subjects are imbued with an unexpected poetry and the equilibrium of an appeased earthling. His first show took place in 1909 in Zurich and was followed, in 1937, by the "Popular Masters of Reality" show as well as by exhibits in a number of European and American museums and galleries.

EPPLE

Bruno Epple was born in 1932 in Hegau, Germany. A professor of history and German, he started to paint in 1955 and was presented in France by a tireless "discoverer" of primitive painters, A. Jacovsky. Thanks to him we have become familiar with this new, interesting and engaging painter. What Epple has to say, he says with precision and with an impeccable finish, but what he has to say is totally unexpected! His half-surrealist, half-hyperrealist vision of everyday scenes (like "Young Girl in her Shower," "A Group of Strollers," or "Cooks with Chef's Cap") confers a magical, somewhat disquieting although magnetic dimension to them, like the mysterious happenings behind a half-open door. We pay attention to this new expression which hides an uneasy temptation. Two of Epple's paintings are in the new Ile-de-France Museum of Primitive Art.

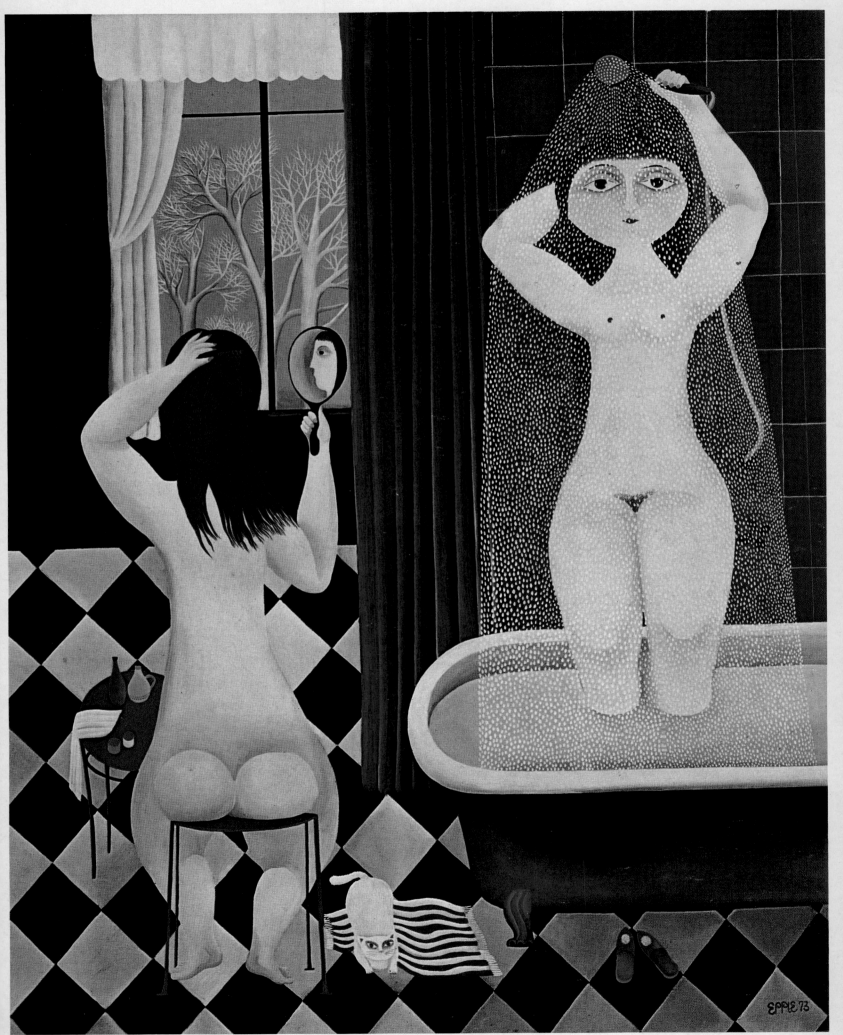

EPPLE: Young Girls in the Bath. 1973. 60 × 50 cm/23.5 × 19.5 in

EVE

Jean Eve was born on October 6, 1900 at Somain (Nord), France, and he died on August 21, 1968 in Louveciennes. The son of a train conductor, he studied at a vocational school in Thiers, then in a mechanical shop. In 1917 Eve graduated from the Ecole coloniale (school for colonial administration) and enlisted in the colonial Spahi regiment in which he served until 1920. Subsequently, he became chief district surveyor for the French National Railways. He married in 1923. In 1924, the Courbet Exhibition at the Petit-Palais and that of the Flemish Primitives at the Louvre were real eye-openers for him. They concretized his long-standing desire to draw and paint. In order to have some freedom and to find a suitable locale for training, he went to work in a car factory in Saint-Denis. His second great revelation, the acquisition of J. Ghenne's book *Portraits of Artists,* launched the next phase of his life. The reading of the book spurred him to visit Kisling, the painter he felt closest to; the latter encouraged him and introduced him to the book's author and to his friends from the "Living Art" team. They all helped him to devote himself to his art. Consequently, Jean Eve retired to Mantes, and feverishly prepared for his first Paris showing in 1930. Unfortunately, the ensuing depression, from 1930 until 1934, forced him to seek a job in Lille. But he missed the light of the province of Ile-de-France, and applied for a job with the local tax office in Paris, settling in Courbevoie. In 1937 he took part in the important exhibition "Popular Masters of Reality" in Paris, Zurich and the United States. In 1939 he had his first one-man show in New York at the Perls Gallery. Thanks to the American exposure, people began to recognize the importance of his talent. It's the period of his masterly paintings of Vexin and the valley of the Epte. Beginning with 1950, he received—finally!—

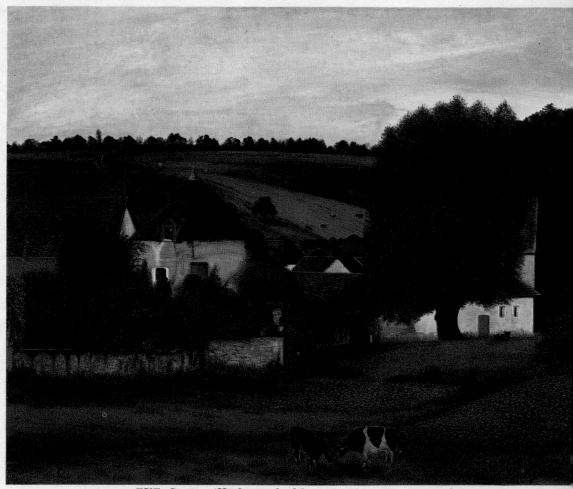

EVE: Spring (High-perched house). 1953. 46 × 55 cm/18 × 21.5 in

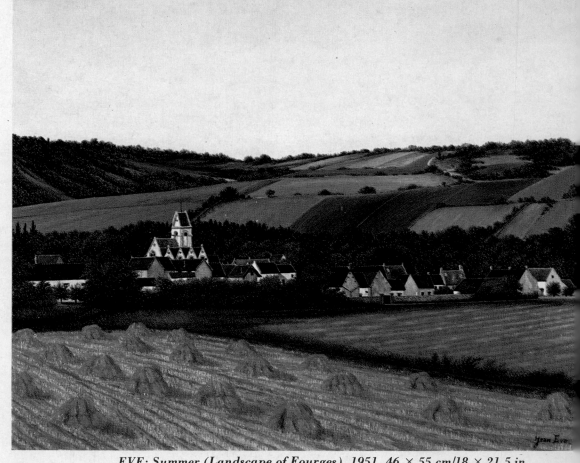

EVE: Summer (Landscape of Fourges). 1951. 46 × 55 cm/18 × 21.5 in

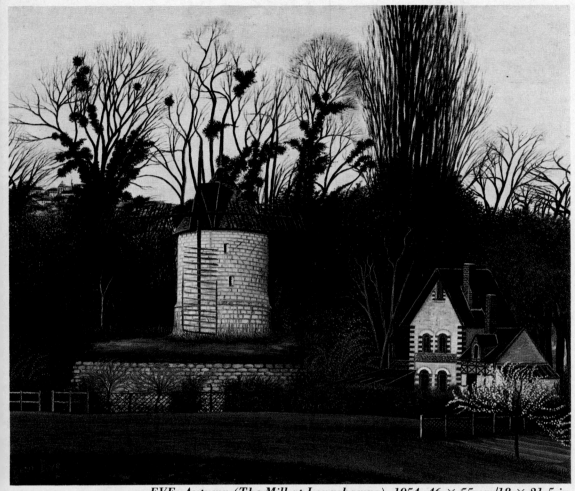

EVE: Autumn (The Mill at Longchamps). 1954. 46 × 55 cm/18 × 21.5 in

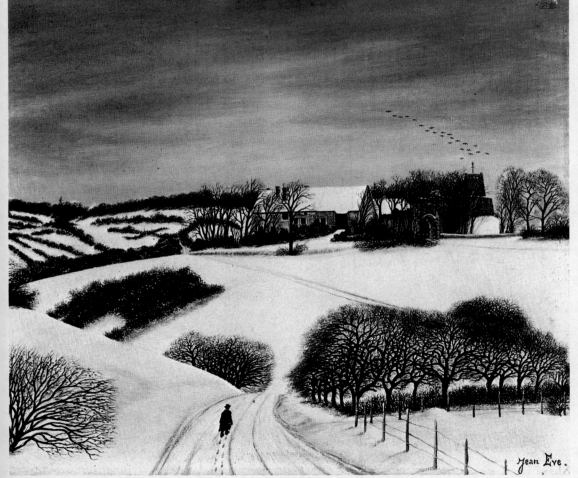

EVE: Winter (Château-sur-Epte). 1947. 46 × 55 cm/18 × 21.5 in

the prizes, decorations and official recognition which his art surely merited but which he was not consciously seeking. He was a very uncompromising person, very honest, very demanding of himself, with the conscience and the love of a craftsman for a job well done and with an innate sense of perfection and sobriety so typical of the people from the Nord district—he was similar in that respect to Rimbert whom he admired. He constantly studied his technique and attached great importance to design. He took the time to work at his own rhythm, to first become saturated with what he wanted to convey in his paintings. Unlike some of the other primitive painters who work on several canvases at the same time, he painted one after the other and always in harmony with the seasons: he always refused to paint snow in spring or blooming apple trees in winter. He painted from nature and used to return to his subject waiting for the precise moment when the light was the same as on the previous day; he worked his colors and reduced his palette of thirty to only fourteen colors. No one was better able to express the meaning of his paintings and of his view of things. "My real studio is Nature . . . Everything is beautiful . . . I would like to be able to draw swiftly enough to catch the exact curve of a flight of grey and white pigeons in the blue sky . . . A landscape painter is someone who is even more patient than an angler. He may be tenacious, but tranquil." This may well be the secret to the peacefulness which permeates Jean Eve's paintings: the happy serenity of work accomplished. His main one-man shows were held in 1930 in Paris, in 1938 in New York at the Perls Gallery, in 1950 in Zurich at the Moos Gallery, in 1951 in New York at Perls', in 1961 in San Francisco at Poweroy's, in 1971 at the Laval Museum, in 1973 a New York retrospective, and in Chicago at the Findlay Gallery. Many museums of modern art have acquired his works.

FEJES

Emeric Fejes was born in 1904 in Osijek, Yugoslavia, and died in 1969. He came from a poor family and earned a living making buttons and combs. He began to paint in 1949, and before using brushes he worked with matchsticks dipped into paint. Maybe it was then that he discovered the delicate line which characterizes his work together with the supernatural colors which imbue his paintings of cities and monuments with their special rhythm. He worked from postcards and all his Venices, his Dubrovniks, his Amsterdams are nothing but poetic transpositions of a systematically anonymous view . . . He has sometimes been compared to Vivin, for their themes are indeed akin, but the source of their inspiration is very different. There is in Fejes' paintings a sensitivity, an emotion which the severity, the starkness and the spirituality of Vivin does not allow. There is surely enough room for both in our little Pantheon, and each of us, according to his heart, will be in harmony with, or will find an echo in, one or the other's work. Fejes' first showing opened in Knokke-le-Zoute, in 1958.

FERRARA

Daniel Ferrara, born July 8, 1906 at Mers-el-Kébir, Algeria, began to draw at age eleven, well before he had to earn a living. He was a sailor, an electrician, a mechanic and then a stevedore in Marseilles. During the war he was deported to Germany. He does not try to follow trends or fashions, he follows his own path, always expresses himself on large canvases in good conscience and with perseverance. His paintings represent either biblical stories, legends or delicate, harmonious landscapes. The contrast between the rough tasks he had to perform to put bread on the table and the softness and delicacy of his style surprise and delight the lover of art.

FIORIO

Serge Fiorio was born in 1911 at Vallorbe, Switzerland. For many years he lived in Haute Provence managing a family farm. The reason for this activity was a return to nature. In 1956 he began to paint and exhibit in Paris, Germany, and Belgium. He is a painter whose style is successfully expressed in the staging and framing of his paintings. His crowds, merry-go-rounds, carnivals are themes in which he excels but his landscapes of Haute Provence and the pictures of his trees are evidence of a different, more surrealist, more tormented, more visionary approach. The great quality of his paintings has led people to include him among the great primitive painters.

FEJES: Dubrovnik (Gouache). 41 × 58 cm/16 × 23 in

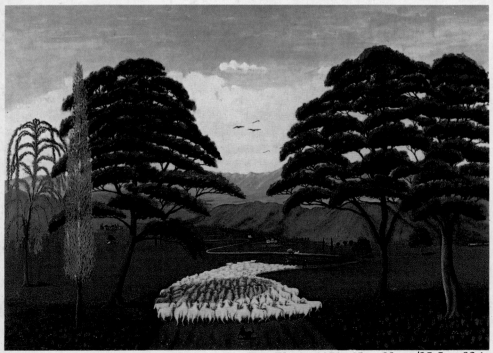

FERRARA: The Flock. 1970. 65 × 81 cm/25.5 × 32 in

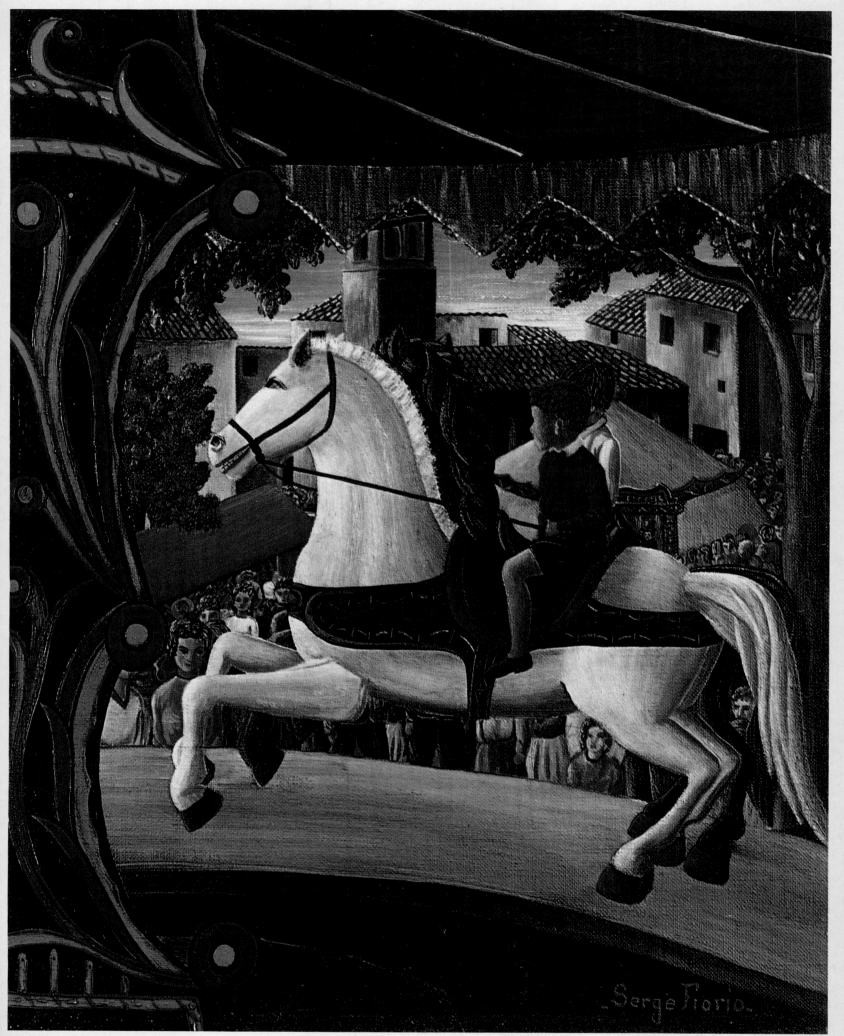

FIORIO: Merry-go-Round. 1971. 40 × 33 cm/16 × 13 in

typical of his style. He is a realist.
But suddenly this realist has a

FOUS: Nativity. 48 × 57 cm/19 × 22.5 in

GENERALIC

Ivan Generalic was born in 1914 in
Hlebine, Yugoslavia. As a child he
used to draw while herding a flock
of sheep with his friend Mraz.
Hegedusic, a painter well known in
Zagreb who originally came from
their village, became interested in
their drawings. He encouraged
them to paint and advised them to
seek inspiration in nature, common
people and everyday things, to
open their eyes and never to copy
postcards. They followed his wise
counsel and Hegedusic organized a
show in Zagreb under the aegis of
a group "Zemlja" (The Earth)
whose goal it was to popularize
artists who were inspired by the
great national traditions. This very
politicized group was disbanded in
1935 but Generalic's contact with
the group allowed him to absorb
some ideas about drawing and
enabled him, with Mraz and Virius,
to found the "School of Hlebine"
whose members were all peasant-
painters.

Unlike Western painters who are
individualists by definition, the
Yugoslavs work together but keep
their personality and the
cohesiveness of their common ideal
intact. Generalic, their undisputed
leader, soon became a painter in
his own right, sure of his skill, the
master of his imagination and his
inspiration. His figures, which
have often been compared to
Brueghel's, have the density, the
opaqueness, the life of the peasants
they portray—but this wedding in
the snow, this dance . . . from
which dream did it spring? On
glass or on canvas, his paintings
have an importance which assures
them a place in international
museums and in the most famous
collections. Since 1938, when his
first show opened in Zagreb,
Generalic has been established as
Yugoslavia's foremost painter.

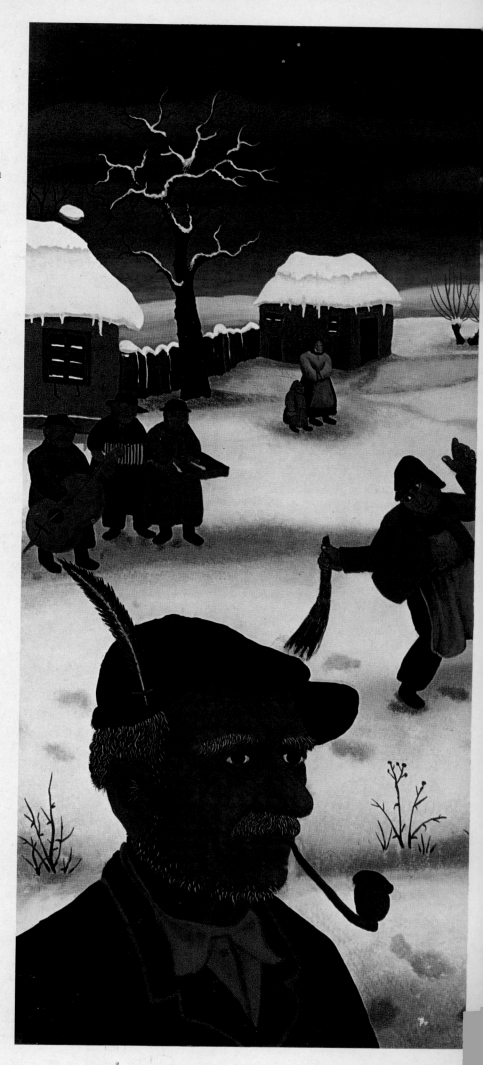

36

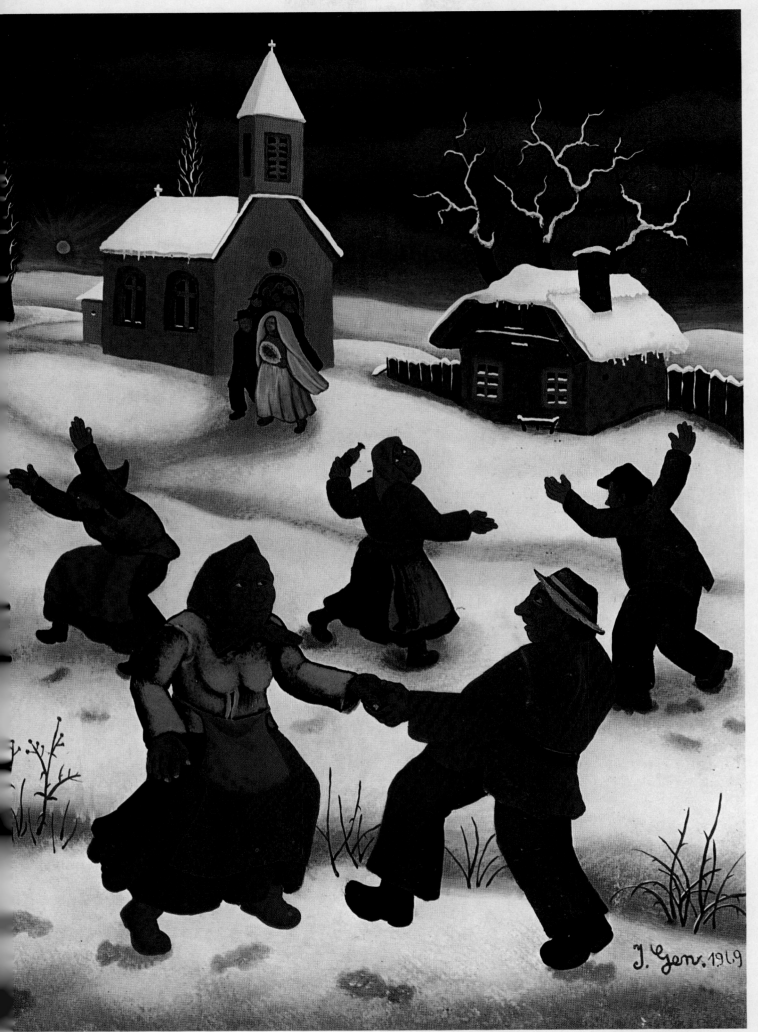

GENERALIC: *Dance in the Village (on glass). 1969.*

GHIGLION GREEN

Maurice Ghiglion Green was born on November 8, 1913 in Cannes, France, where his father was a construction worker. Because of his parents' divorce he had to forego his studies toward an architect's career, and instead became a croupier at a casino in Cannes. During the war he hid in the Creuse region where the view of nature induced him to pick up a brush and canvas. In 1947 he returned to his job as a croupier but was already hooked and couldn't refrain from painting during the entire day. His health suffered because of it but he was soon able to make a living with his art. His paintings reflect a simple but precise, spontaneous and clever poetry. This simplicity and this cleverness may seem to be contradictory, but, although the design is simple and instinctive, the execution is precise and skillful. The alliance of these so rarely united qualities produces the density of this serene art.

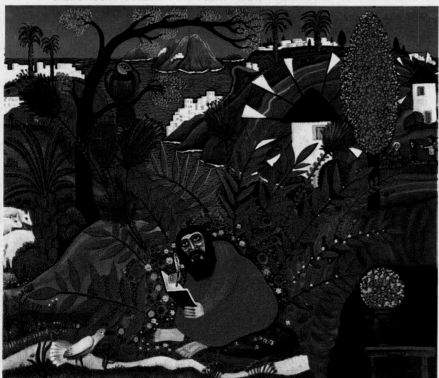

GHIGLION GREEN: Ile Saint-Louis. 1953. 33 × 41 cm/33 × 16 in

GHIN: St. John at Patmos. 1974. 38 × 46 cm/15 × 18 in

GHIN

Joseph Ghin was born in 1926 at Hornu, Belgium. He worked as a house painter but on the advice and thanks to the moral support of his wife he gave up this trade and devoted himself to his vocation. Ghin is a gifted artist with an immense lyrical inspiration. We can expect a lot from this tender, peaceful man with an opulent vision of things, of cities, of biblical or political scenes, nurtured by legends, imaginary transmutations, unexpected superimpositions. He is a story teller; each of his paintings is a long tale blending the essence of things with their visual existence. A landscape of Greece, for him, is the story of Saint John at Patmos. He is haunted by good and evil, by the beautiful and the unsightly. Look at this "Port of Antwerp." In a well delineated clearing he places beauty and love; and then, next to this limpid paradise, he depicts all manner of evil doings, lustful demons, drunkards and thieves who seem to have escaped from a gloomy, disquieting yet infinitely tempting nightmare . . . Ghin is a mystic, inspired, opaque—a poet.

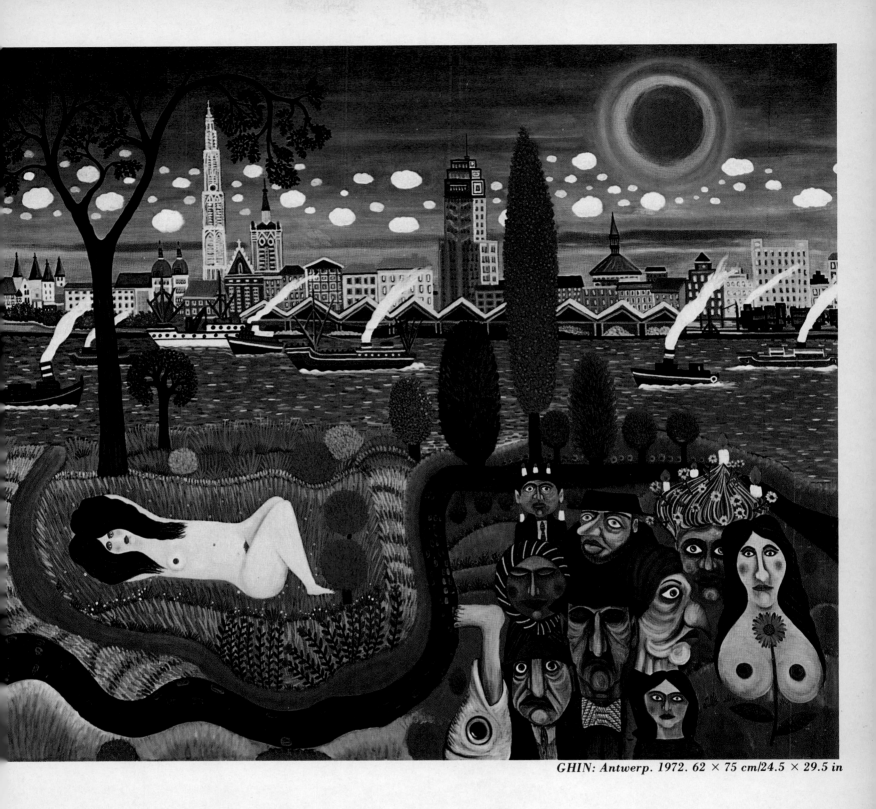

GHIN: Antwerp. 1972. 62 × 75 cm/24.5 × 29.5 in

39

GRANDMA MOSES

Grandma Moses, actually Anna-Mary Robertson, was born 1860 in New York and died in 1961. She was of Irish origin and in 1887 married a farmer; they had ten children. Her story wouldn't be remarkable at all except that she started to paint, suddenly, at age 70, when farm work became too strenuous for her. Then, to keep herself busy, she took to painting and, of course, since all work deserves a reward, sold her paintings for a dollar each! Discovered and appreciated, maybe sooner than any other artist, because of her advanced age, she exhibited in New York and received from President Truman the "Women's National Press Club Award." She remains the most famous of the American primitives, and her paintings are very beautiful "reportages" of the farmers' life. The Paris Museum of Modern Art has one of her most famous paintings, "The Dead Tree."

GRIM

Maurice Grimaldi, alias Grim, was born on July 23, 1890 at Raon-l'Etape (Vosges), France. He died in 1968. He was a post office employee and his supervisor was the painter Vivin. His paintings were "discovered" at one of the shows organized by the post office. From 1957 on, he started to devote himself entirely to painting. Did he draw his inspiration, like Utrillo, from an excessive use of the fruit of the vine, or did he derive from his memory and his native Vosges the ferment which generated his green paradises? In any case he is a painter of jungles, the beloved subject of the most brilliant primitive painters, and he remains the undisputed virtuoso of greens; more than sixty shades of green have been counted in his paintings. His wooded landscapes, his forests, above all his trees give us the physical and fragrant sensation of a nature of our dreams, yet one whose powerful materiality is frightfully present.

40

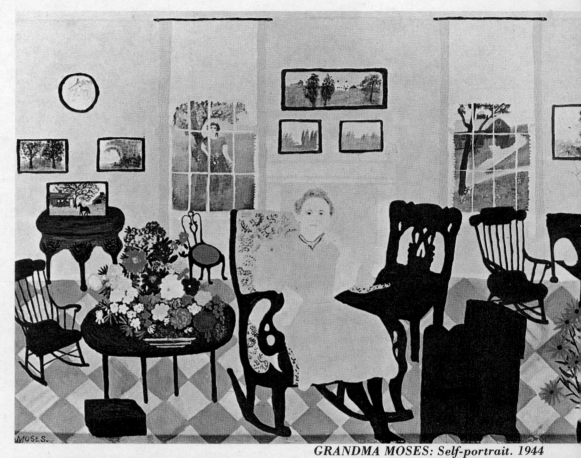

GRANDMA MOSES: Self-portrait. 1944

GRIM: Jungle. 1965. 46 × 55 cm/18 × 21.5 in

HYPPOLITE

Hector Hyppolite was born about 1894 in Saint Mark, Haiti; he died in Port-au-Prince in 1948. A many-faceted personality, he was above all a priest, a voodoo priest, with all that the extraordinary ritual of this strange and fascinating religion, brought from Africa by millions of black slaves, carried with it. This cult, which is so intimately imbued with Catholic symbols and practices, inspired Hyppolite. He was discovered by an American professor, Dewitt Peters, who was struck by the primitive exuberance and quality of his pictorial expression. In 1944, the professor decided to create the Haitian Art Center. This Center brought together several real artists, such as Philomé Obin, Rigaud Benoît, and André Pierre. The Cuban painter Lam and André Breton encouraged these artists and appreciated their unconscious surrealism. Their source of inspiration, the voodoo cult, is inexhaustible, intensely rich in "concrete-abstract" contrasts: life and death, body and spirit, Jesus and fetishist practices. It is an art of trances, dances, screams and explosive color. It is, together with the Yugoslav painting, the only example of communal type primitive art.

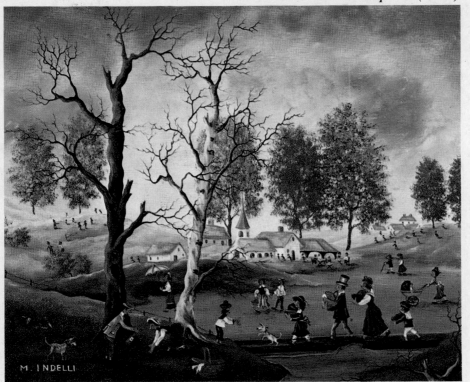

HYPPOLITE: Pin-up Girl (Haiti).

INDELLI

Mimma Indelli was born in Italy, at Signa. She began to paint in 1942. Her first exhibition took place in 1945. In the beginning she leaned slightly towards surrealism but she changed her style when she discovered the Flemish painters whose technique she studied. In 1945, several important critics noticed in her paintings certain affinities with Brueghel's and Cranach's. She remains very much influenced by the Flemish primitives and combines her vision with her surrealist reminiscences. This results in very arresting compositions and real miniature paintings. In 1964, she participated in the exhibition of "Contemporary Primitives" at the Charpentier Gallery in Paris.

INDELLI: The Picnic. 1970. 19 × 24 cm/7.5 × 9.5 in

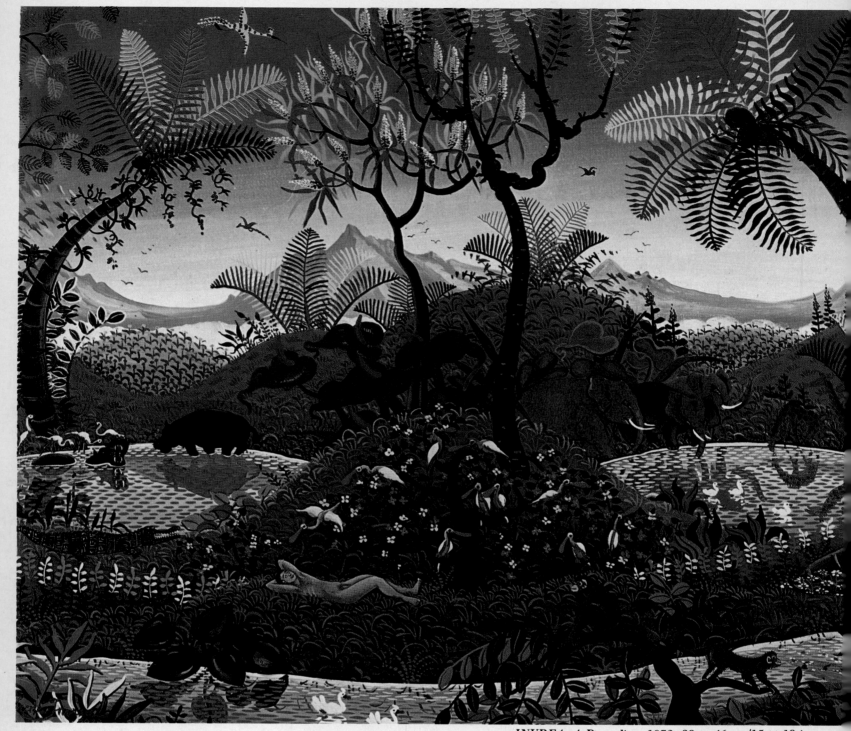

INVREA: A Paradise. 1972. 38 × 46 cm/15 × 18 in

INVREA

Irene Invrea was born in 1919 in Langhe, Italy. After the death of her husband she devoted herself to painting as a diversion from her loneliness. She was very much nurtured by French culture and is incomparably well informed about Versailles and Louis XIV. We surely wouldn't guess this from her paintings, where, in contrast, she paints surrealist jungles. In those paintings we find black panthers side-by-side with pink flamingos, and small pearl shaped clouds mixed in with the flowers on the lawns. Invrea admires nature's work, she dreams it, paints it and offers it to us to see and love. Man's works she loves intellectually, but she doesn't offer them to our eyes. Maybe one day, in an extraordinary vision, she will combine her two loves. We would, no doubt, discover some tropical Trianon hidden behind a Versailles Jungle, the result of a cosmic upheaval and the promise of even more wonderful and unpredictable paintings.

KOVACIC

Milo Kovacic was born on August 25, 1935 in Gornje Sumi, Yugoslavia, near Hlebine. Kovacic, a peasant and livestock breeder like most of the other Yugoslav painters, learned from Generalic's school. But he was able to free himself from his teacher's strong personality and impose his transposed vision on the same environment. He is the painter of quiet, big, powerful people who are not at all anguished by their surroundings. They are full of intense life; they seem to be uplifted by the supernatural, phosphorescent light which spiritualizes their universe. There is a great breath of air in these landscapes. The sky and the water which surround the gold diggers add a fantastic dimension to this painting. The couple in the foreground of the "Picnic" scene suggests love in a familiar setting,

KOVACIC: The Gold Diggers (on glass). 1960. 60 × 85 cm/23.5 × 33.5 in

but the strange figure leaning against the barn in the "Rustic Scene"—is he nefarious, a thief or a caster of spells? Ever since his first show in 1954, Kovacic has participated in numerous international exhibitions of primitive art.

KOVACIC: The Picnic (on glass). 1972. 50 × 70 cm/20 × 27.5 in

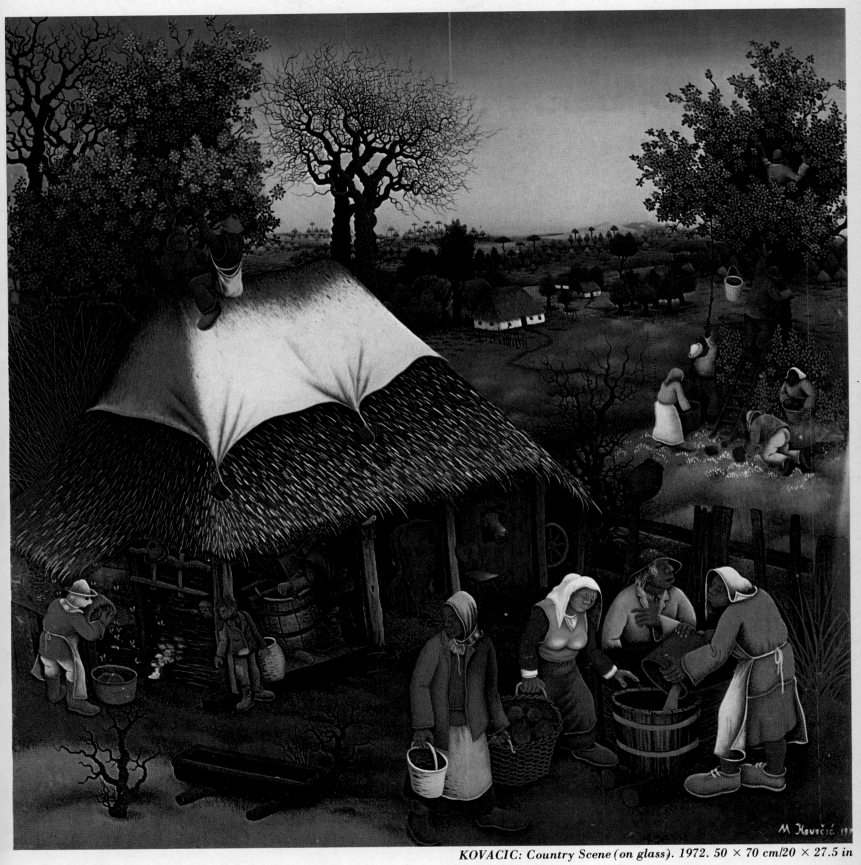

KOVACIC: Country Scene (on glass). 1972. 50 × 70 cm/20 × 27.5 in

KWIATKOWSKI

Jean Kwiatkowski was born in 1886 in Poland; he died in 1971. At a young age he was deported to Siberia because of his political ideas. Kwiatkowski escaped and at age 17 he took refuge in France. During World War I he volunteered for the French Army and obtained French citizenship. For his own pleasure he associated with people from Montparnasse, and to make a living he became a designer of high fashion textiles. But painting is his passion and he exhibits his works in the 1938 Exhibition of the "Independents." He had to muster all the patience, faith and uncommon obstinacy to persevere, his only reward being the joy of painting, until his miraculous meeting with Lozada Echenique who fell in love with his paintings, encouraged the artist and, with rare skill and love, publicized his works.

Kwiatkowski is a poetic realist, a virtuoso of muted, deep colors with a tender vision of landscapes transfigured by a dream, bathed in a spiritual light where everything is harmonious, calm, tranquil. He plays with an incomparable range of greens, blues and grays and handles them with a sentient technique. Somewhat later his palette lightened and he attached a lot of importance to the sky and the clouds. He didn't paint more than a dozen paintings per year. In 1956 his work was finally exhibited in various Parisian galleries. In 1968, three years before his death, a retrospective showing took place at the Museum of Naive Art in Laval.

KWIATKOWSKI: Dreamboat. 1966. 97 × 130 cm/38 × 51 in

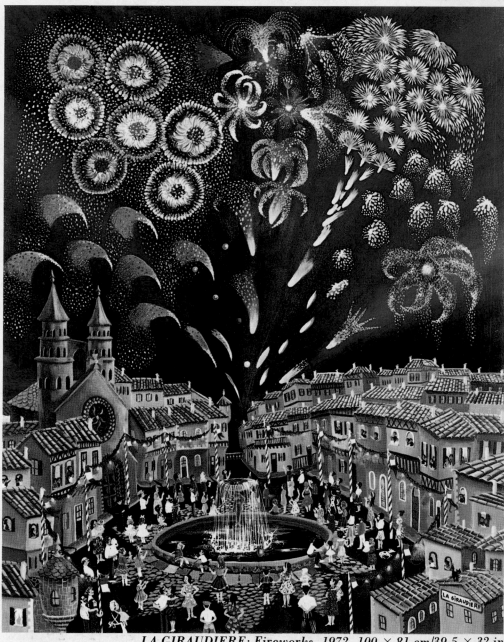

LA GIRAUDIERE: Fireworks. 1972. 100 × 81 cm/39.5 × 32 in

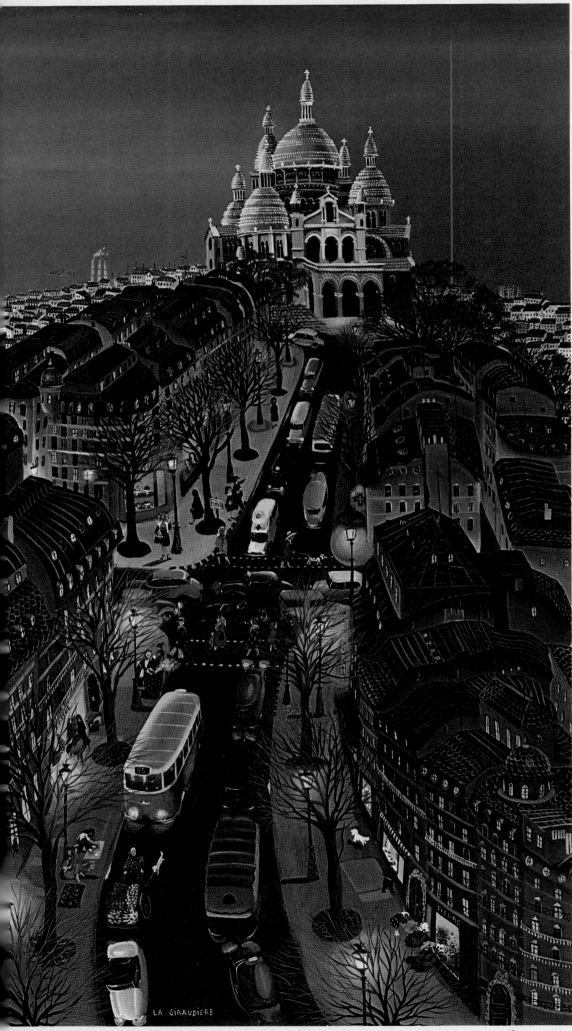

LA GIRAUDIERE: Church of the Sacred-Heart. 1973. 130 × 89 cm/51 × 35 in

LA GIRAUDIERE

Mady de La Giraudière was born on April 3, 1922 in Toulouse. Most recently, she lived in Lavelanet in the Ariège region. Her adolescence was spent in a Toulouse boarding school where she relived all the intense memories of her first ten years in the family's house. Flowers, colors, warmth, odors, everything she was deprived of and which in her village was translated into festivals, processions and flower gatherings became grist for Mady's brushes. Her parents refused to let her study at the Academy of Beaux-Arts but did allow her to attend a few art classes. Happily, academism had no hold on Mady, she went her own way, by hook or crook—and she won. She invents, innovates and seeks to translate her everyday world—so it will forever be remembered, because it is beautiful—into images. She tackles the most difficult subjects, those that require skills which she did not learn. But that is without importance because she succeeds; she succeeds because her sincerity sustains her. She is an incomparable story teller of a true-life world with its flowers, its familiar animals, street processions, fireworks, balloons, children's games. Mady, like Rousseau and Blondel, often accompanies her paintings with little poems or sentimental tales: "I am not carrying a message. I am only passing through this rough painful torn world. I would like to stop the war and give peace. What can I do, a poor crusader without armor, with much love and a little painting?"

LAGRU

Dominique Lagru was born in 1873 at Percy-les-Forges (Saône et Loire district); he died in 1960 in Paris. He had an unhappy childhood and was unable to study. He worked successively as a shepherd, a plasterer, a miner. He contracted tuberculosis and lived in misery. Lagru used the free time his illness forced upon him to help others. He was a militant unionist and he helped organize the workers of the municipal library of the 13th district of Paris. He used this occasion to read voraciously and acquired the education of which he had been deprived. At age 75 he felt he had read everything, and wanted to express it, share it with others. Hence he started to paint. And the eclecticism of his reading was reflected in his paintings: biblical subjects, the first men on the moon, stories of shipwrecks, and storms. His first show was held in 1951 at Romi's Gallery, when he was 78 years old.

LASKOVIC

Ivan Laskovic was born in 1932 in Batinska, Yugoslavia, and became a mailman in Zagreb. His encounter with the founder of Yugoslav primitive school of painting, professor Hegedusic, was also his encounter with his real vocation. He started to paint and very quickly broke away from the Hlebine style—first and above all because of the importance he attached to the design. Others, like musicians who can't read notes, can do without design because of their great lyrical inspiration; but he had to work with precision. He worked like a miniaturist: he almost x-rayed his landscapes, especially his trees, stripped of their leaves by a long winter. These bare twigs and branches are transformed into rhythmic lines which punctuate these deserted plains, the villages which nestle around the church tower. His painting technique on glass has reached such quality, such

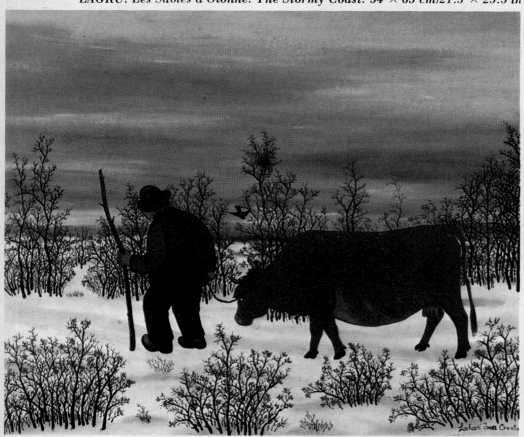

LAGRU: Les Sables d'Olonne. The Stormy Coast. 54 × 65 cm/21.5 × 25.5 in

LASKOVIC: The Orange Cow (on glass). 37 × 45 cm/14.5 × 17.5 in

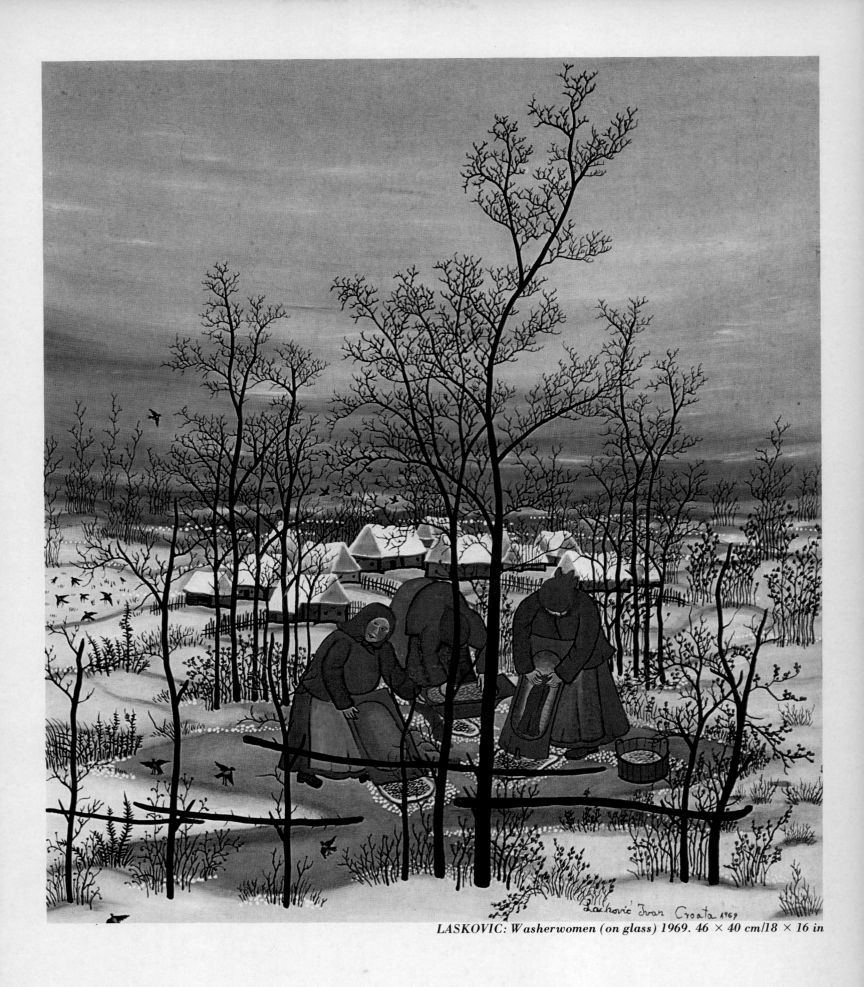

LASKOVIC: Washerwomen (on glass) 1969. 46 × 40 cm/18 × 16 in

perfection in its precision that it
permits him to develop the
nuances of his palette, to obtain
unequaled transparencies and a
starkness that displays great vigor.

LEFRANC

Jules Lefranc was born May 12, 1887 in Laval; he died in Paris on May 21, 1972. He, too, came from the same region as Rousseau the customs man. Lefranc was a hardware merchant, as was his father. His encounter with painting dates back to his youth when he saw Claude Monet painting his marine landscapes. Monet, laconically but firmly, encouraged him to paint. Consequently, Lefranc started painting but he did not follow in his mentor's footsteps. For him painting was an acute, structured retranscription of the world that surrounded him. In 1928, he sold his business and devoted himself entirely to painting. He lived in Belleville, exhibited for the first time in 1937, and became acquainted with a friendly circle of artists and intellectuals: Aragon, Rimbert, and Lagru among them. He had a very personal view of the world: he saw it as fixed, frozen, inhuman: and he worked with tools which are generally not used by painters: a T-square, dividers, rulers. He composed his paintings with mathematical precision but this technique was humanized by lively, brilliant, varnished colors as well as by a very surrealist method of framing. Some of his work is reminiscent of Magritte's. He was also a collector of naive painting, and it was becuase of his initiative and the important donation to his city that the French Government decided in 1967 to establish the first Museum of Naive Art in the city of Laval.

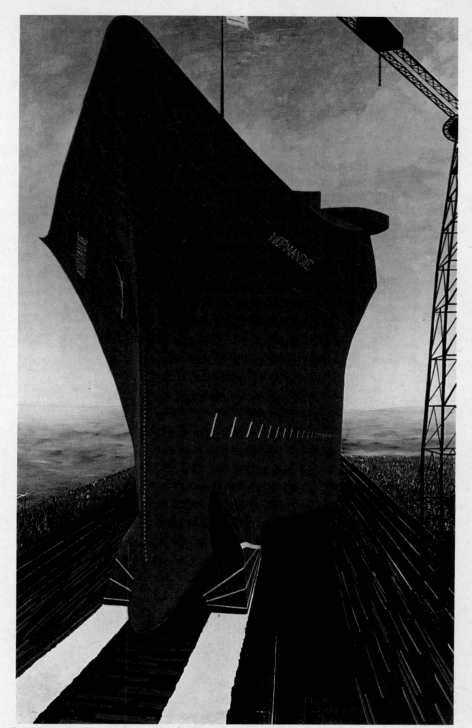

LEFRANC: The Normandie before the Launching. 1933. 117 × 74 cm/46 × 29 in

LEFRANC: The House of my Birth. 55 × 70 cm/21.5 × 27.5 in

50

MELIES

Georges Méliès was born in 1861; he died in Paris in 1938. He is certainly the most unexpected man in our selection—well known and recognized as a famous and celebrated cinematographer, Méliès was, on the other hand, practically unknown as a painter and draftsman. How can we not recognize here, in this spectacular and meticulous stage setting, all the ingenuity of this born illusionist, this prestidigitator and charmer? All the themes and the style of the primitive painters are here: careful presentation of detail, enchantment, the supernatural, the fantastic, fiction, poetry. This is the work of a man who believed above all in the fascination of the animated picture.

MORAÏS

Crisaldo d'Assuncao, alias Morais, was born in 1932 at Pernambuco, later renamed Recife, in Brazil. He lives in Sao Paulo and works for an airline. He is another primitive painter who has been brought to our attention by Anatole Jacovsky, this veritable "Geiger counter" of naive painters. Morais is a visionary. He refuses to paint anecdotes; he listens to his silence. His canvases serve as a backdrop for strange divinities. In "Yamandja," the blue sky is a counterpoint to the intense sea, the Goddess fascinates us because her eyes are fixed on us. This primitive vision of mysterious spirits from the sky opens a new poetic universe, magical in its simplicity, for us.

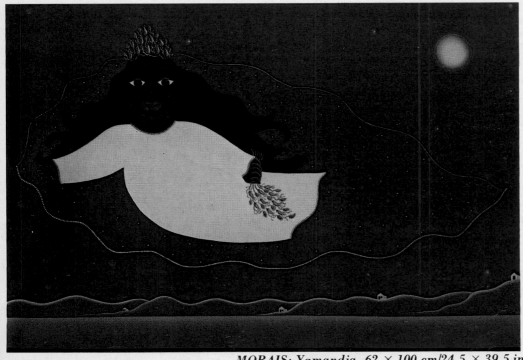

MELIES: The Magician. 1890

MORAIS: Yamandja. 62 × 100 cm/24.5 × 39.5 in

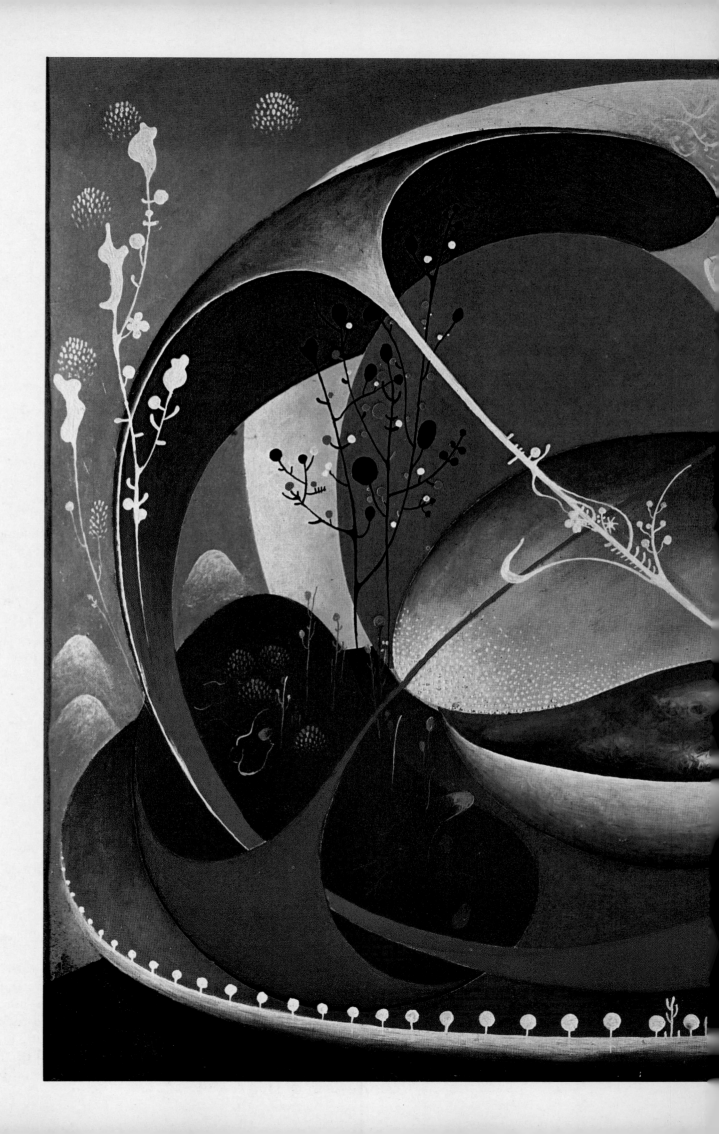

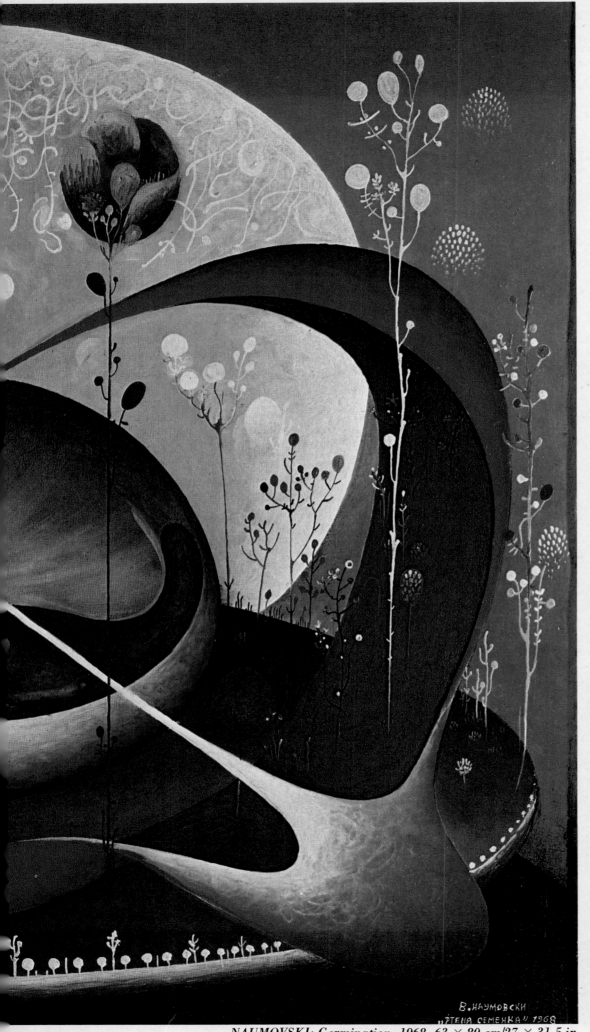

NAUMOVSKI: Germination. 1968. 63 × 80 cm/27 × 31.5 in

NAUMOVSKI

Vangel Naumovski was born March 22, 1924 in Ohrid, Yugoslavia. He worked as a shepherd, draftsman and botanist and attended some classes at the local Art Institute. He sculpted in wood at first and painted for himself, but at last exhibited his work in 1954. With a group of botanists he studied the bottom of lakes and it was there that he discovered what he expresses in each and every painting—a moving, deformed, fascinating world. The lascivious forms of these flowers, these algae evoke the curves of bodies which the painter almost never portrays but whose underlying, sensual presence we feel. He goes beyond the naive expression of the commonplace, the living reality, in order to produce a lacustrian landscape, taken from the secret and silent bottom of the lake by his obstinate and meditative eye. His undulating tropical creepers, his elongated, translucent spheres, criss-crossed suddenly by curved lines and unfurled flowers are on the outer limit of abstract art—if you will allow this impudence. Naumovski is a great colorist and one of the most efficient contemporary purveyors of dreams. He explores the source of all our emotions.

NIKIFOR

NIKIFOR: *The Two Bell-Towers (watercolor). 18 × 22 cm/7 × 8.5 in*

Nikifor was born about 1893 in Lemkowszeryzna, Poland; he died in 1968. He was an absolute self-taught painter, almost deaf-mute, uneducated. He had to beg for a living where he lived, in the mountains near Cracow. He drew on everything he could find: paper, pieces of cardboard, wood. And he sold his works—watercolors, gouaches and crayon drawings—exactly the way he would have sold postcards. Since he was known to be illiterate, people have often tried to discover the meaning of the letters which follow one upon the other at the bottom of his paintings. There is none. He simply drew these letters the way he would have painted another church steeple, or a Pope, or maybe it was a way for him to sign his paintings? His works were often copied especially after collectors and art lovers started buying the works of this authentic primitive. Consequently, he had a stamp made of his likeness which appears on the back of all his drawings. But the surest stamp of authenticity is the collector's eye which will always recognize the subtlety of his colors and their incomparable charm.

O'BRADY

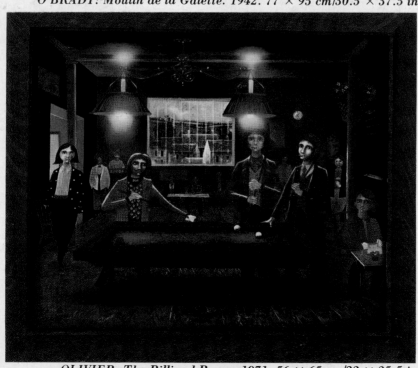

O'BRADY: *Moulin de la Galette. 1942. 77 × 95 cm/30.5 × 37.5 in*

OLIVIER: *The Billiard Room. 1971. 56 × 65 cm/22 × 25.5 in*

Gertrude MacBrady, alias O'Brady, was born in 1901 in Chicago. Her life would have been a long calvary, for she was ill and suffered crisis after crisis, relapse after relapse, had it not been for the most fortunate stroke of luck, the discovery of her talent for painting, in 1935, at Bougival, a region surely blessed by God. Painting became a shield against her illness, a passion which almost led to her recovery. During World War II she was interned in Vittel, and there she executed with rare brilliance portraits of her fellow camp inmates.

In 1945, an exhibition of "American Portraits" revealed her to the public. She was the most poetic reporter of a Paris that is

long gone, a more humane Paris with its craftsmen, its small shops, signs offering "wood coal"; a reporter also of a countryside without factories and without pollution, of boating parties and broad-rimmed sun hats. She also painted airplanes and their pilots, "those marvelous flying crazies and their funny machines"; she painted all this comfort, all this ease of living with love, conscientiousness, tenderness—she who had such a hard time surviving. Painting must have been for her a "break", an unhoped for reprieve, but unfortunately, a fleeting one because she became ill again and retired to Italy. There, she has lived in the throes of recurring crises of mysticism which for a long time now have deprived her of her will to paint.

OLIVIER

Jean Olivier was born March 16, 1923 at Chauny, France. He has tried his hand at a number of professions and has worked as a photographer, service station attendant, painter at the Paris flea market, and others, before devoting himself entirely to painting in 1965. He is a poetic, other-worldly fellow, somewhat of a whippersnapper, who has found a style well-suited to present to us the strange fauna which inhabits his mind: young women, tender and pale children, families united under a lamp in a conventional but curiously disquieting scene. An uneasiness, a wonderment emanates from these nevertheless familiar reunions. And it is this uneasiness, this wonderment that delights us. Jealous of his universe, Olivier locks it inside his very canvases: he paints all around it, in a deceptive way, the frame that protects his people, hems them in, fastens the buckle.

PETIT

Danielle Petit was born April 29, 1921 in Morhange (Lorraine), France; her father was an officer.

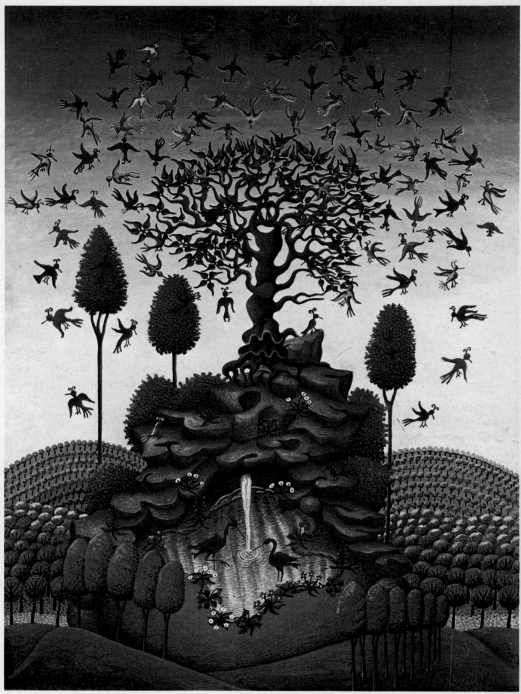

PETIT: The Plumed Tree (Gouache). 1974. 41 × 32 cm/16 × 12.5 in

She obtained a job with the State Administration but a serious illness, tuberculosis, which she caught in the wake of the war, forced her to spend four years in a sanatorium. Upon her release she married a teacher, started to work again, but suffered a serious relapse and had to stop working. The Administration may have lost a valuable worker but painting has gained a new artist—an artist full of ideas and endowed with a fertile and personal imagination. Her method reminds us of the illustrations of the Books of Hours, but the anecdotal aspect of her subjects is counterbalanced by the originality of her imagination. Danielle Petit has embarked upon a voyage, an exploration of her memory, not in search of time lost, but in an attempt to resurrect a reality which her eyes have seen and which her imagination transposes. Her paintings are always the history of a story: they take a long time to read and they are full of surprises; they are a glimpse of a happy world, a window onto the great beyond.

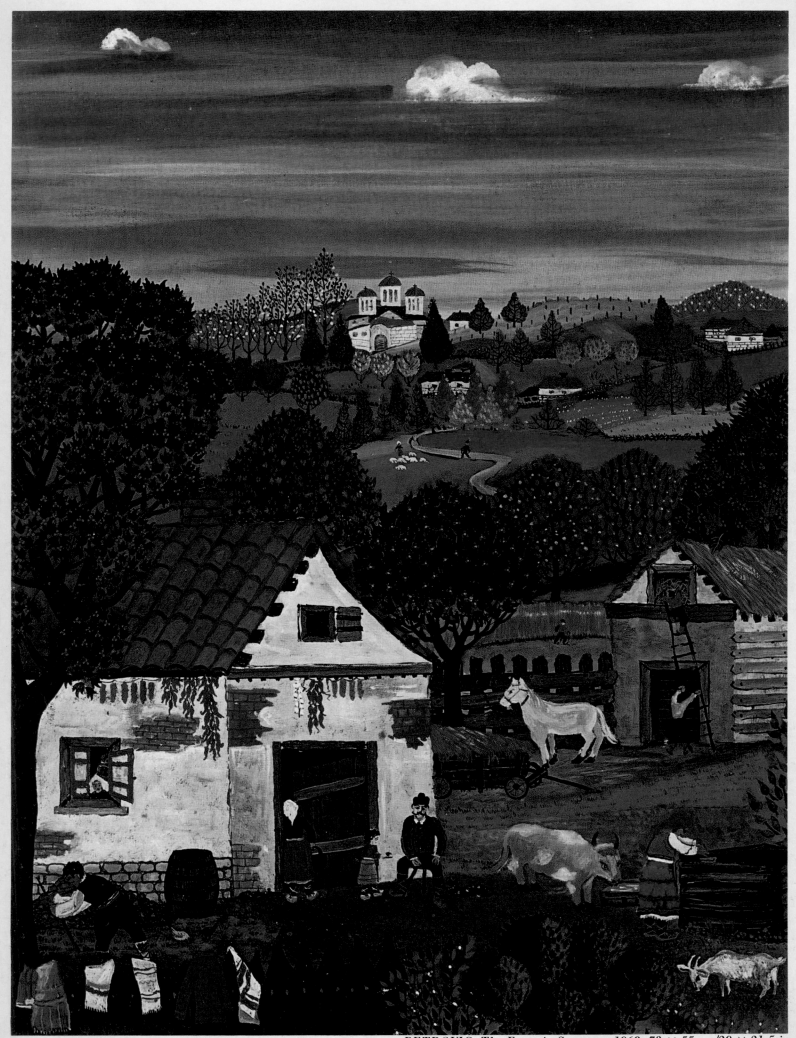

PETROVIC: *The Farm in Summer.* 1968. 73 × 55 cm/29 × 21.5 in

PETROVIC

Ljuba Petrovic was born in 1928 in Nis, Yugoslavia. He first worked as a farm worker and then for the municipality of Nis and, presently, as a house painter-decorator. He also executed a number of frescoes and mosaics for his city. His first paintings have been exhibited in group shows with other peasant painters. He is "classical" in his transcription of the environment. A naive realist par exellence, he is concerned with design and attentive to color, an element which he handles with great skill. Above all, he has a gift for composition. Indeed, the equilibrium and the impression of peace which emanate from his paintings are generated by his composition. Is it also due to the ever present monastery, the innocence of his mellow, snow covered countryside or the luminosity of his sumptuous but discreet skies? We don't really know, but Petrovic's alchemy spurs us to follow his endeavor. Petrovic's first one man show in Geneva, in 1973, was an immediate success and confirmed our opinion of the artist.

PEYRONNET

Dominique-Paul Peyronnet was born at Talence, France, in 1872; he died in Paris in 1943. He worked in a print shop, specializing in lithography and soon familiarized himself with the use of colors and the works of artists. Peyronnet began to paint in 1920. He was a complex person, fascinated by an art which he pursued with extreme care. His encomiums on painting are famous, even if they are not very much appreciated. To the rather laudatory critique which Maximilien Gauthier published in 1937: "His works are masterpieces whose intense dramatic power no one can dispute, he is an original talent, he imitates no one," he added himself: "1) He is also the only painter whose works may be viewed from close-up as well as from a distance; 2) The only painter who imitates people and things from nature; 3) The only painter who is inimitable." Peyronnet did not develop an inferiority complex . . . But he was, in fact, a remarkable artist and quite inimitable. The clouds, the seas, which he observed during his vacations at Villers, help us understand Charchoune's approach to art.

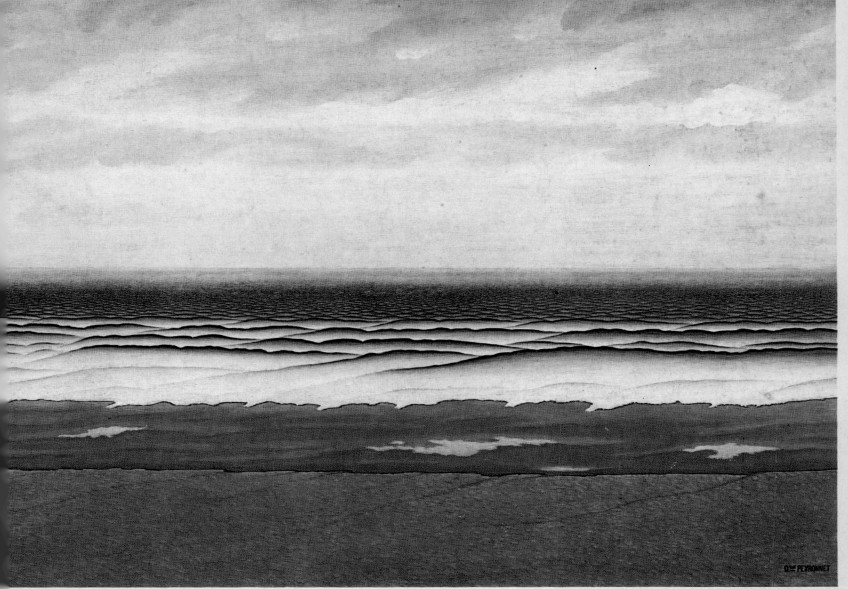

PEYRONNET: The Sea. 1939. 54 × 81 cm/21 × 32 in

RABUZIN

Ivan Rabuzin was born on March 27, 1919 at Kljuc, Yugoslavia. A carpenter and cabinetmaker by profession, he started to paint after World War II but not before taking some art courses. He separated himself completely from the other Yugoslav painters of rural inspiration. He expresses to the highest degree the enchanted world of the mind. His visionary imagination suggests to us a magic spectacle of landscapes and people in a surrealistic relationship but executed in curved lines, circles, spheres which suggest the perfection of his creations. His small, pearly, balloon-shaped clouds cap all his paintings, his softly rounded, thicket covered hillocks, all the villages, his dream worlds, are locked in, shut tight. And all this is often crowned by a sun—the source of life—and covered with giant, sky devouring flowers. The symbolism of his painting is a happy one. The magic of Rabuzin's colors commands our attention and widens our horizons. Rabuzin must be recognized not only as the greatest Yugoslav painter but also as one of the greatest contemporary painters. His importance has been underscored by, among others, the Rousseau prize which he received in 1969 in Bratislava. But the artist is continuing his quest—he believes in the eternity of the suns, the flowers, the lights. And he says so himself: "I am listening, I am keeping my ear to the ground. And I am there. I am alive." He is indeed an inspired witness.

RAYB

Raymond Bussereau, alias Rayb, was born June 17, 1897 at Saint-Chéron (Seine et Oise); he died in Paris in 1975. For 42 years he worked as a head clerk in a bank. He suffered the loss of his wife but he was able to overcome his pain thanks to painting. Like O'Brady, like Desnos, like Lagru, he was able to transform his sadness into joy due to his painting which allowed him to escape in his marvelous hot air balloons, surely the most poetic means to cross the skies. He used a magnifying glass to paint the many people, the animals, the small flowers of his green lawns, his green youth, his aspirations. And he did all this with great modesty.

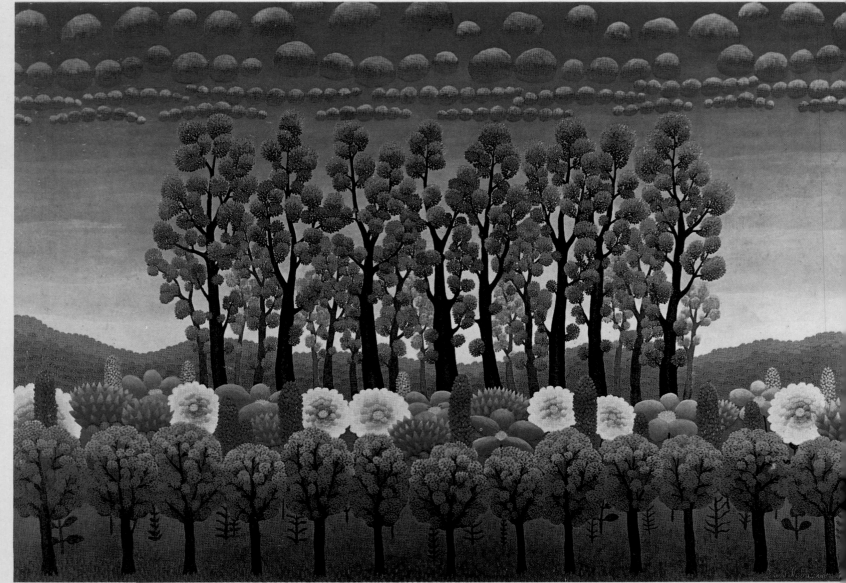

RABUZIN: Ring of Flowers. 1967. 81 × 116 cm/32 × 45.5 in

RIMBERT

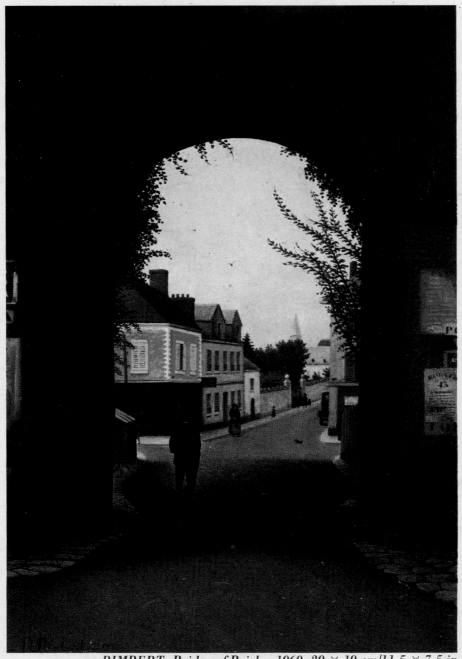

RAYB: The Brass Band. 1967.

RIMBERT: Bridge of Bricks. 1969. 29 × 19 cm/11.5 × 7.5 in

René Rimbert was born in 1896 in Paris, the son of a picture framer. All his life he lived in Paris in the Saint-Sulpice quarter. He worked for the post office until 1956 when he retired. But he has been painting for a long time and in 1920, for the first time, he sent a canvas to the Exhibition of the Independents. Gromaire noticed his work and encouraged him in his endeavor. But the real force behind his inspiration, the one that underlies all his paintings, is Vermeer, unquestionably a highly desirable mentor. He has indeed often been compared to the Dutch masters: Rimbert irresistibly reminds us of these masters because of the precision, the honesty and the quality of his paintings and also because of the scruples, the sense of decency, the refusal to produce the easy effect or anodyne. He in fact excels in producing subtle color harmonies. Everything is justified, deliberate, necessary. Of course, he paints very little, about four to five paintings a year, for such perfection requires great patience.

Max Jacob said long ago: "Rimbert has no anxiety about the fate of his painting. It is finished before it has been started, it is ready to let itself be painted. He tackles his canvas with the kind of peacefulness that brings us close to God and things." In 1937 Rimbert took part in the "Popular Masters of Reality" show and in 1964 he exhibited with the "Contemporary Masters" at the Charpentier Gallery, and regularly at the Berri-Lardy Gallery. Rimbert is one of the great contemporary primitive painters. We "listen" to his paintings as well as look at them. They are really the "chamber music" of naive painting.

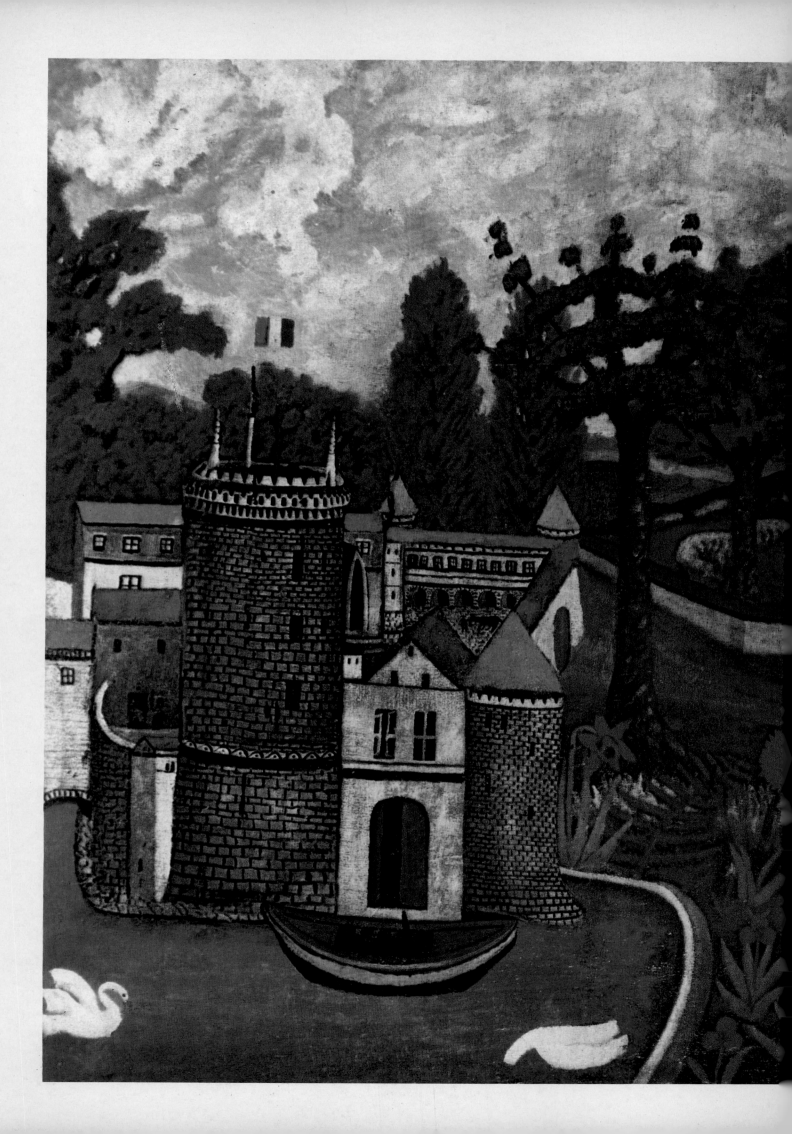

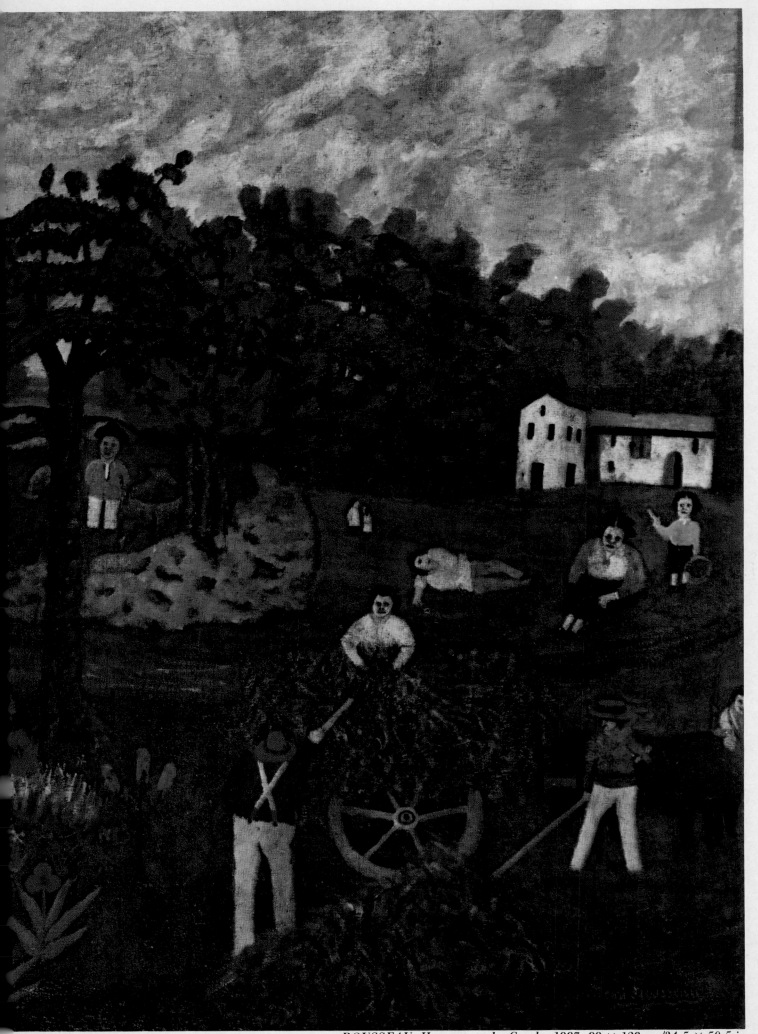

ROUSSEAU: Harvest at the Castle. 1887. 88 × 128 cm/34.5 × 50.5 in

ROUSSEAU

Henri Rousseau, called Le Douanier (the customs official) was born in Laval on May 21, 1844, and died in Paris on September 3, 1910 at the Necker Hospital. The son of a tinsmith, he had his future laid out before him because tradition dictated that he follow in his father's footsteps. But young Henri only liked poetry and music, and at age 19 he had not been able—nor would he be able in the future—to obtain his high school diploma. He enlisted in 1864 and joined his regiment as a clarinetist. He left the army in 1868 and married Clémence Boitard who became the great love of his life: she was partly of Czech origin by way of a grandmother and the vivid recollection of this woman still fascinated her faithful husband four months before he died, when he executed his last masterpiece, "The Dream," which was accompanied by an explanatory poem.

Rousseau obtained a job with the local tax bureau in Paris. He owes his nickname "le Douanier" to this post. In 1880, he started to paint; in 1884, he lost his wife and immediately asked for his early retirement so he could devote himself to what had become a passion, namely painting. He took up residence at 2 Pérel Street where—to support himself and at the same time to surround himself with friends—he gave violin, drawing, poetry and watercolor lessons to people from the neighborhood. In 1886 he sent a canvas to the "Show of the Independents." Without the existence of this exhibition it is probable that his whole work would have remained unknown. Jarry, also a native of Laval, discovered him there and tried (because of his love for the practical joke or his admiration for everything that scandalizes) to launch his career. Apollinaire, Picasso, Gauguin, Seurat and Delaunay became his friends and the renowned W. Uhde became interested in him. In 1899, he

remarried. His second wife died in 1903. Rousseau very much enjoyed his relations with the famous but in spite of it he remained the "petit bourgeois" conditioned by his birth all his life. He had to come to grips with, on the one hand, his penchant for honors, dignity, frock coats and, on the other, the immense horizons of his imagination which led to the jeers and the mockery of the "right-thinking" conformists. Since he had a weakness for the mysterious, he believed in spirits; on the practical side, he joined the Order of Masons. This accounted for his nomination to a professorship at the Ecole Philotechnique and this act also won him a decoration from the Ministry of Education. He loved decorations, and above all it helped him get out of jail, a place where he landed as a result of his immeasurable candor. It concerned his involvement in a mysterious bank swindle masterminded by his friend Sauvaget; but the innocent Rousseau had seen no wrong in this scheme.

In 1895 he painted "The War" and in 1896 "The Sleeping Gypsy" which is rightfully being considered the beginning of modern primitive painting. Of course, he was quickly scoffed at and ridiculed by the critics as well as by Courteline who had bought some of his canvases for his Horror Museum, but the great painters—Redon, Toulouse-Lautrec, Gauguin, Picasso, Signac, Braque—quickly recognized his talent. And Robert Delaunay wrote: "In a large painting by Rousseau a blade of grass is as 'finished,' as developed and of the same importance from the point of view of form as his immense, pure, transparent sky which in his paintings occupies such an important place. This is because in his art the surface is the principal point of reference and in this manner he creates the spatial sensation without resorting to perspective." Famous for his jungles, Rousseau, in fact, painted only a dozen exotic canvases. All his other paintings represent

villages, Parisian neighborhoods, landscapes, flower bouquets, rivers and portraits but they are less well known to the public because they were not controversial. The fantastic vegetation (wholly invented, of course, since his famous "trip to Mexico" only took place in his mind) was so real to him that while painting it he had to open the window in order not to be overcome by the pungent odor of this growth! In 1907 he executed the "Female Snake Charmer"; in 1908, a year of great inspiration, he painted "Father Juniet's Horse and Cart," "The Poet and his Muse," "The Rabbit's Meal" and "The Soccer Players." In 1908 the great banquet offered by Picasso at the Bateau-Lavoir—maybe a practical or affectionate joke—touched Rousseau deeply because he felt himself accepted by his peers. He was a conscientious, self-taught painter, proud of the extremely "finished" quality of his work which he diligently researched, sketching and tracing from encyclopedias the plant motifs which he then enlarged. He instinctively did what others had learned in art schools. His rather simple composition is always supported by his colors—Rousseau was an exceptionally fine colorist whose "blacks" were admired enormously by Gauguin.

Rousseau never received the just reward for his genius. He died poor and alone and was buried in a common grave until one year later when Apollinaire raised the money to buy a plot for him. He was one of the painters whose work was the object of lively polemics. As Maurice Garçon, one of the lawyers at his trial, later recalled, he had been accused of being a "naive painter." He was accused of it during his lifetime and beyond because of his scandalous ignorance of the art of painting, and the questioning of his ignorance. He was, in fact, "a displaced person," always out of balance socially but in total equilibrium with the masterly expression of his art.

ROUSSEAU: Military Hospital. 60 × 40 cm/23.5 × 16 in

ROUSSEAU: Paris Bridge. 1898. 33 × 40 cm/13 × 16 in

SCHWARTZENBERG: London. 37 × 46 cm/14.5 × 18 in

SCHWARTZENBERG

Simon Schwartzenberg was born on September 20, 1895 in Paris. He was in charge of a hosiery business until he started painting in 1952. His first show opened ten years later at the Bénézit Gallery. He was attracted by all art forms but his greatest sensitivity can be found in his pictorial script where the usual principles and known concepts are shunted aside in order to arrive at an art which transforms the commonplace. Building fronts, pearl-studded rainbows, iridescent poetry, water, boats, transparent and veiled skies, and all this is a transposition, a revenge for the war, the suffering which exists but shouldn't! Schwartzenberg is finally being recognized as one of the great visionary primitive painters. His works are represented in the greatest museums, including the Paris Museum of Modern Art.

SCHWARTZENBERG: Moscow. 1971. 60 × 76 cm/23.5 × 30 in

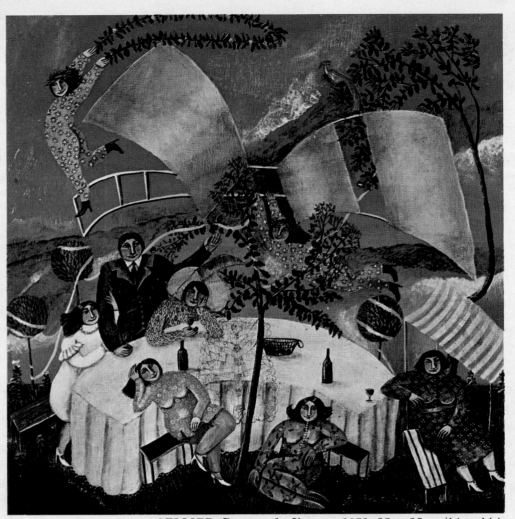

SELLIER: Dream of a Voyage. 1972. 35 × 35 cm/14 × 14 in

SELLIER

Dominique Sellier was born in 1952 at Grand-Lucé in the Sarthe region. She is the youngest painter in our collection. Dominique started painting at age 15, maybe inspired by the abundance of flowers and plants cultivated by her parents in their nursery, just like Bauchant. But what has grown in Dominique Sellier's garden is different, it's a growth of uncommon dreams, gardens filled with dignified acrobats, musical comedy notables, obese middle-aged swimmers. There are buoys, hoops, balloons and barrel-vaults, and an almost invisible flying carpet, in her paintings. The people she draws, at once genial but suspicious characters move to a happy rhythm: they are plump but free from gravity. There is a secret law at work that accords each a special state of grace, a particular freedom. Dominique Sellier paints on a small scale using oils on wood. Her colors are subtle and they add to the precision of her compositions and the freshness of her imagination. Her works have been exhibited, in 1973, at the Bénézit Gallery, and since then, in group shows in Italy, the United States and Israel. In 1976, her work was seen together with the works of Bauchant, Blondel, Caillaud, and Séraphine, in the very beautiful "Fairyland of Naive Art" exhibition which Max-Pol Fouchet had organized at Le Vésinet.

SELLIER: City with Ladies. 1975. 35 × 35 cm/14 × 14 in

SERAPHINE: *The Paradise Tree.* 1929. 195 × 129 cm/77 × 51 in

SÉRAPHINE

Séraphine Louis, sometimes called Séraphine de Senlis, was born in 1864 at Assy (Oise region). Her father was a watchmaker and her mother a maid, and she was W. Uhde's housekeeper. He encouraged her painting and helped her obtain large size canvases. Her paintings have been compared to stained glass windows which she might have observed in churches but this explosion of color resembles nothing we have seen before. Her unique subject bursts, gushes forth thickets of leaves, of feathers, eyes and mouths, in a huge mystical delirium. Indeed, Séraphine was very pious. In her wretched room, a candle was burning under the small statue of the Virgin. But at the same time she was consumed by an unsuspected exaltation and possessed by a kind of demented symbolism which was locked in her old and sickly body like a monster. Her inner confusion projected her towards a dazzling paradise which the weight of the earth had denied her. She became so demented that she had to be hospitalized and she spent the last years of her life in an insane asylum.

SKURJENI

Matija Skurjeni was born on December 15, 1898 at Veternica, Yugoslavia. Although of peasant stock, he worked successively in the mines, for the railroad and finally as a house painter. He was about 26 years old when he started to paint. He took a few evening courses with a worker's art group in Zagreb. But it was in the end as a loner, as a European primitive painter, that he was best able to express himself. He tries to fit his abundant dreams within the confines of the canvas and to transfer his interior universe onto the painting. He used to say that his canvases were the narrative of his nights . . . sometimes calm and structured, sometimes reserved, chaste and mildly symbolic. Exhibition of his works follow each other regularly in the world ever since his first, in 1947.

SKURJENI: The Kiss. 1966. 138 × 83 cm/54.5 × 32.5 in

TOUSSAINT

Raphael Toussaint was born in 1937 at La Roche-sur-Yon, France. He was always attracted by different art forms and for 15 years he practiced classical vocal music; he has been both a musician and a painter since 1964. He gave up his career as an accountant to devote himself to art. He is a quiet person and his paintings reflect this characteristic: he organized his career calmly and participated in all major exhibitions. He works conscientiously, his paintings have that very "finished" look and are bathed in a soft, golden light. He never hesitates to tackle very opulent compositions where every detail counts because he draws very well and the delicacy of his line adds to the precision of his paintings. Structured but poetic, his works delight the eye and stimulate the mind.

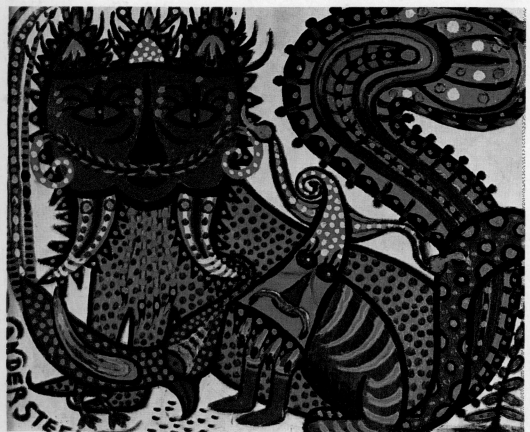

TOUSSAINT: Cat with Flowers. 1973. 19 × 27 cm/7.5 × 10.5 in

VAN DER STEEN: The Fantastic Cat. 1954. 38 × 46 cm/15 × 18 in

VAN DER STEEN

Germain Van der Steen was born July 7, 1897 at Versailles. Until recently he managed his paint supply business near the Etoile. But he is really a supplier of colored dreams, a paint merchant lost in the night, since he painted the night; he is a visionary who had come from an unknown planet where cats reign supreme. This fantastic, matchless bestiary, inhabited as it is by prodigious cats which have nothing in common with the feline but seem to be either exuberant or frightful fetishist divinities, this bestiary is a rainbow of color, an unforgettable fairyland, a delirium, a fireworks. These magic cats go beyond the boundaries of the canvas, they are alive! What goes on in the mind and in the heart of a man who for many years has been asked for a bottle of turpentine by customers who were not aware that they were dealing with an ailurophile visionary? Painting, more so than music or literature, reveals the unsuspected . . . the devils share in reality.

VIEILLARD

Lucien Vieillard was born in Toulouse on December 24, 1923. He is a lawyer and works in a bank's legal department. In 1966 he became aware of his talent. It has been said that his landscapes, his structures resemble working drawings. There is a lot of rigor and austerity in his paintings of streets without people, houses with closed shutters. Why? Maybe he doesn't like crowds and he doesn't want to depict people for they don't change, or change very little. But he wants us to see that which soon will no longer be visible. He wants to give an account of those cities that are about to disappear, the environment that is turning ugly, the soul that is dying. He wants to show them to us in their completeness, in their original color, the way his faithful memory represents them.

VIEILLARD: Garden and Turret of the Capitol of Toulouse. 1971. 50 × 61 cm/19.5 × 24 in

VIVANCOS

Miguel Vivancos was born on April 19, 1895 in Mazarrona, Spain; he died in Cordova in 1972. He came from a poor family, lost his father at an early age and started working when he was 13, first as a mechanic, then as a stevedore, house painter, etc. He took part in the Spanish Civil War on the side of the Republicans, became a commander; after the defeat, he exiled himself to France. He spent five years in a camp for Spanish refugees. Finally, he was freed and in Paris this soldier found work painting on silk. He did an outstanding job and decided to paint on canvas. André Breton prefaced the catalogue for his first exhibition which was an immense success. This courageous freedom fighter was 50 years old when he traded in his arms for brushes and was able to transcribe all that beauty which he may well never have seen since he was too busy defending it. He expressed it with poetic simplicity. His landscapes, his flower bouquets spread on unforgettable place mats, his skies,

VIVANCOS: Shepherds by the Sea. 1969. 52 × 64 cm/20.5 × 25 in

his seas are soft, calm, and minute in detail. Forgetful of his scars and struggles, resentments and suffering, Vivancos the painter has triumphed over Vivancos the commander.

VIVIN: Shipwreck.

VIVIN

Louis Vivin was born in July 1861 at Hadol (Lorraine) and died in Paris in 1936. The son of a teacher, he began to draw at a very early age. He became an itinerant worker for the post office, and after 43 years on the job in an administrative position he became a postal inspector. His first exhibition took place around 1889 at the "Salon des Postes." He then exhibited, as did many others, at the "Foire aux croûtes" in Montmartre where W. Uhde, as well as Monsieur Bing, discovered him. Bing always defended his works, even sometimes at the risk of bankrupting his gallery. At age 61, he devoted himself entirely to painting. He remained oblivious of all art schools, friends and critics. He executed his canvases obstinately with a preference for the linear which led him to the brink of abstraction. But this structure, this austerity is alleviated by the use of color and by the infusion of a spirituality which seems surprising in such a geometric design. This pertains mainly to his architecture, his streets, his urban landscapes. His other themes—gardens, flowers, the sea—show less evidence of his personality but they touch us because of the love and joy they try to transmit. He is one of the five great naive artists, together with Bauchant, Bombois, Rousseau and Séraphine.

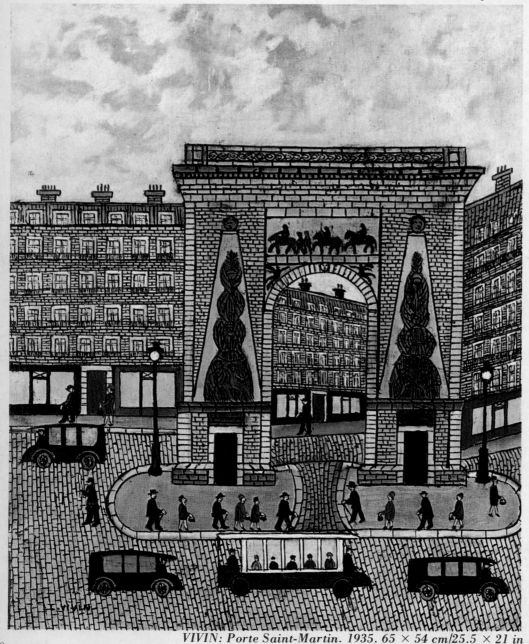

VIVIN: Porte Saint-Martin. 1935. 65 × 54 cm/25.5 × 21 in

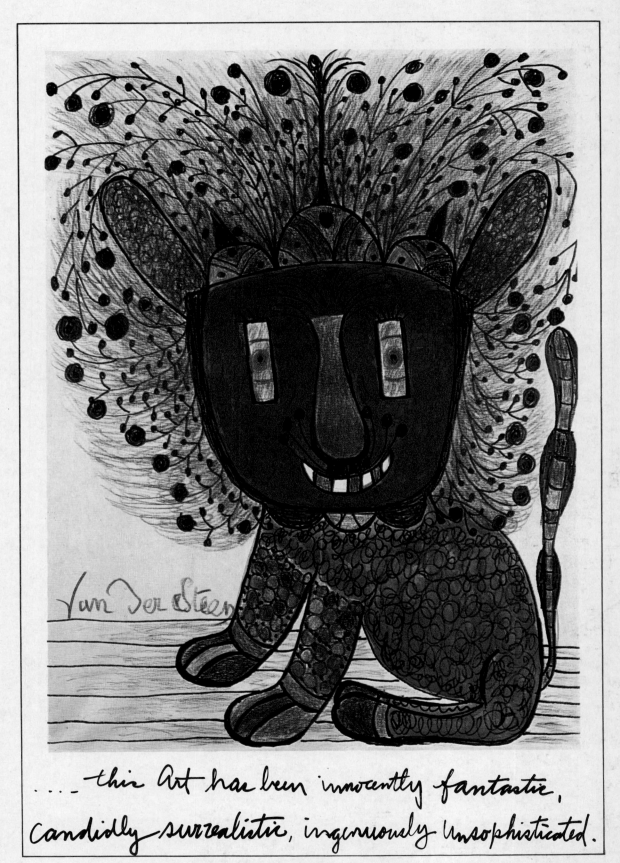

..... this Art has been innocently fantastic, candidly surrealistic, ingenuously unsophisticated.

VAN DER STEEN: The Cat. (Color Crayon). 1967. 81 × 65 cm/32 × 25.5 in

We wish to thank
the Collectors, Museums and Galleries
who were kind enough to give their help
and among them:
Mr. Jacovsky
Ms. Daniaud; Ms. Diwo; Mr. Gaudrat; Ms. Montag;
Ms. Olivé; Ms. Sechet.
Musée d'Art moderne, Paris; Musée du Louvre, Paris; Musée d'Art Naïf Henri Rousseau, Laval;
Musée du Petit Palais, Geneva; Musée di Belli Arti, Lugano; Musée de Neuss, R.F.A.
Galerie Antoinette, Paris; Galerie Beno d'Incelli, Paris;
Galerie Berri-Lardy, Paris; Galerie Benezit (r. de Miromesnil), Galerie Benezit (r. de Seine), Paris;
Galerie Mona-Lisa, Paris; Galerie 93, Paris; Galerie Seraphine, Paris;
Sydney Janis Gallery, New York; Galerie Bettie Thommen, Basle.

We also wish to thank, among others,
those who allowed us to reproduce their works in this volume:
A B C Décor: "The Normandie before the Launching" (J. Lefranc), p. 50;
Baron de Lindegg: "Military Hospital" (H. Rousseau), p. 60;
Dina Vierny: "Fat Farm Lady on her Ladder" (C. Bombois), p. 22;
"Porte Saint-Martin" (Vivin), p. 70;
Lozada Echenique: "Dreamboat" (Kwiatkowski), p. 46;
"Self-Portrait 1944" (Grandma Moses), p. 40 is copyright by Grandma Moses Properties, Inc., New York.

Photographs:
C. Basnier–A. Lefèvre–Paris-Match–P. Perquis–Diathèque C.C.I.
Photothèque USIS–and X. . .